BALTHUS

BALTHUS

Text by
JEAN LEYMARIE

SKIRA
RIZZOLI
NEW YORK

First published in 1979 (size $14\frac{1}{2}'' \times 13\frac{1}{2}''$). To
this new edition have been added three more color
reproductions of recent works and an *Itinerary*
giving an illustrated survey of the artist's major
paintings in museums and private collections.

© 1982 by Editions d'Art Albert Skira S.A., Geneva

Translated from the French by James Emmons

Published in the United States of America in 1982 by

RIZZOLI INTERNATIONAL PUBLICATIONS, INC.
712 Fifth Avenue/New York 10019

Library of Congress Catalog Card Number: 82-60071

ISBN: 0-8478-0458-5

Printed in Switzerland

SOME ARTISTS ARE PROVIDENTIALLY SINGLED OUT AS BEARERS of the Golden Bough. They abide, pilgrims of eternity, keepers of the spirit, servants of beauty, traversing their time and all its transitory flux and reflux, set on a steady course, intent on timeless values.

Before we turn to the work of one such artist and try to approach it in silence, as if it were that of an unknown author, let us state his name and identity, with their full resonance and the aura surrounding them. In the world he is Count Balthazar Klossowski de Rola, descendant of an old Polish family of many branches, and by nationality a Frenchman. In the realm of painting he is Balthus, an ideogram of two well-tuned syllables fraught with far-reaching echoes.

This painter of today, who like the old masters has become famous under his nickname, keeps to himself the facts of his private life, around which floats a halo of legend; and his confidential pictures, widely dispersed and seldom seen, have aroused both misapprehension and fascination.

With a lofty delicacy and an obstinate observance of good manners, Balthus holds aloof from the trivialities of fashion and publicity; he avoids any confusion between the social sphere, in which he shines easily, and the private domain in which the work of creation is carried out in seclusion.

This book, essentially a magnificent album, offers not a summing up but a selection of his paintings, together with a few drawings, mostly recent ones: all are reproduced as faithfully as possible. For this series of fine plates, whose sequence suggests the ideal private showing and which transpose into their own register the irreplaceable impact of the originals, custom calls for a text of presentation, at best pointless if it allows the pictures to speak for themselves and necessarily hazardous if it attempts to interpret them. Every painter conscious of the irreducible character of his art dislikes the idea of exegesis; his sole advice to art lovers is to look and look again, carefully and silently. Take the example of Poussin. Apart from a few words about the subject and the care he gave to the execution, he never bothered to describe the pictures he sent to his friends and purchasers, knowing that they would soon have them before their eyes: "I shall make no further effort to describe it to you," he wrote of one of his pictures to his faithful friend Chantelou, "for it is something that must be seen." For years it has been the steadfast purpose of Balthus to carry his paintings—in which the storytelling element has ceased to exist—to such a point that one feels their completeness without being able to give it utterance. The emotion peculiar to painting, since it takes possession of us inwardly, has the effect of doing away with words, of reviving within us the coenaesthesia anterior to speech.

Two of the common detours that carry us away from art and its central concerns are the scholarly commentary and the biographical pitfall. Whatever the éclat and singularity of his destiny, the true painter aspires to merge into the corporate body of common experience and

anonymous existence, and he only reveals himself to the full in the universal substance of his work, from which in return can be gleaned some telltale signs of his background and schooling. From the odd fact of having been born on the 29th of February, so that his birthday only comes round every four years, Balthus has a sense of eluding the set chronology of other adults and preserving indefinitely his essential treasure: the dateless time and absolute world of childhood, in which his visions are rooted, and of which the name, the nickname, or if you will the pet name, by which he is known as a painter, comes as an ever-present reminder. For the classical philosopher and savant, like Descartes, childhood is an inferior state which he would gladly have skipped in order to gain sooner the command of reason. But for the poet and artist, especially since Romanticism, since the break with the past that came with the industrial era, childhood is the privileged source of the holiday spirit and the indispensable recourse against growing mechanization. "Where children are," says Novalis, "there is the golden age." Associated with the free play of instinct and the pure gaze, childhood possesses that transpiercing power of the imagination which the English poet Wordsworth, who has so memorably evoked the scenes and sensations of early life, calls *the soul of nature*, and through which reality, that of daily life, not that of fancy, is made to reveal itself in its primordial force and its hidden order. Balthus assures us, and this we may take as his cardinal testimony, that he has never ceased to see as he saw when a child.

He spent his childhood in a still countrified quarter of Paris, on the eve of the First World War, and then in Geneva, a crossroads and meeting place. It was at an impressionable age that he discovered the Swiss landscape and the age-old ways of Swiss life so well rendered by the painter René Auberjonois and the novelist C.F. Ramuz. Brought up in a family of culture and distinction, one that moved in a cosmopolitan society and stood on easy terms with the best spirits of the age, a family in which painting was appreciated and practised as a hobby, he found as

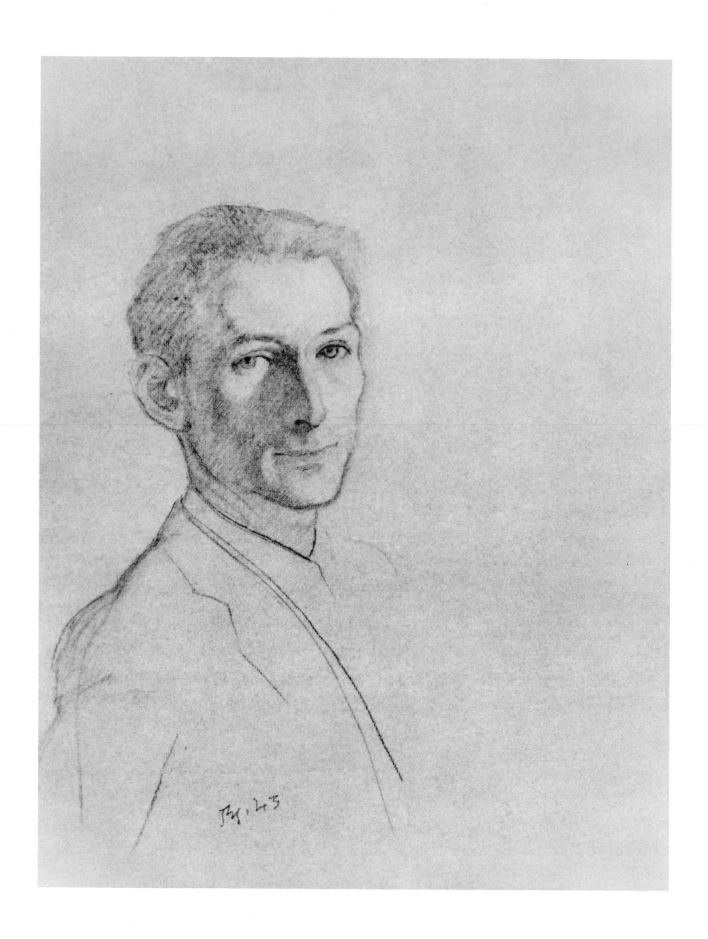

Self-Portrait.

1943. (24 ³/₄ × 18 ³/₄ in.)

a boy in his immediate entourage such men as André Gide, Pierre Bonnard, Rainer Maria Rilke. The latter, with his intuitive understanding of children, saw his artistic gifts and fostered them. While Balthus was still a schoolboy, Rilke saw to the publication of a set of his drawings, for which he wrote by way of preface his first text in French. The great European lyric poet welcomed his young friend to his postwar home in the Valais, a land of vine-growers and shepherds, then still intact and remote from modern life, a land of Alpine glens and ancestral rites where Rilke found renewed inspiration and his final haven. He was amazed at the exceptional knowledge of Far Eastern art and ways acquired very early by his young protégé. For the poet who had given him the Chinese novels of Victor Segalen to read, Balthus illustrated the classic novels of old China, carefully reconstituting the atmosphere and setting. In his eager, ever-ranging curiosity he had found the continent of his choice, the fabulous Celestial Empire to which he betook himself in thought and which he dreamt of saving from Western contamination. Through his father, a historian and connoisseur of wide attainments, and author of a standard monograph on Daumier, he disposed of the latest publications on the arts and civilizations of the entire world. In the course of summer holidays at Beatenberg, a mountain resort from which the eye embraces the Lake of Thun and the peaks of the Bernese Oberland, he was struck with a sudden illumination. Sitting out of doors, looking through a new book on Chinese and Japanese painting, he realized all at once the glaring coincidence between the pictures in the book and the actual view of lake and peaks before him. Chinese painting, in which the preponderant landscape is designated by the binomial ideogram signifying "waters and mountains," had for him the same power of example and revelation that Egyptian sculpture had for Giacometti. This decisive confrontation with the Swiss and the Chinese landscape is the basis of his unfashionable conviction that art should be (in the words of Cézanne) "a harmony parallel to nature" and not tend towards abstraction, justifiable though this may be in periods of crisis and disarray, when man is cut off from his environment, when he

has lost confidence in surroundings not yet fashioned to his uses or becoming ominous. A little later his father, having also acquainted him with Piero della Francesca, whom he described as the Cézanne of the Renaissance, took him to Aix-en-Provence, to the countryside around the Sainte-Victoire mountain and its cone answering to the golden number, where the master of an art of marked Chinese affinities learned his metrics and left his imprint.

At sixteen Balthus decided to devote himself entirely to art and returned to Paris. For want of that relevant schooling which none of the living painters whom he admired could or would transmit to him (and the disappearance in our time of the traditional craftsmanship is to him a matter of keen regret), he had to pursue his apprenticeship alone, outside the academic circuits, through the patient study of the old masters and the age-old discipline of copying their pictures. For three months, with single-minded concentration, he worked in the Louvre on a copy of one of Poussin's masterpieces, *Echo and Narcissus*, a theme taken from Ovid. No easel painting, perhaps, so magically interweaves the four elements of nature around the human drama: the fatal spring, the resplendent earth, the stormy sky, the funerary torch; and none, through the shimmering modulation of cool tones and warm tones, achieves so well the miraculous accord between rhythm and sensation, volume and light, colours and values. The dying Narcissus lies with his head among the flowers that bear his name, springing up on the spot where he dies. Balthus noticed that in his peasant sturdiness and princely beauty Narcissus bears a strange resemblance to Rimbaud—and to himself. And Echo, the heart-broken nymph wasting away in pink and ashen tones upon the rock into which she is changing, seemed to him to be painted with the accents of Corot, according to those movements of resurgence and anticipation by which art is governed. He saw too, in the course of his slow approach (what X-ray photography has since proved), that under the final composition lie two initial compositions, this complex build-up of the picture giving the pigments all their plenitude and

vibrancy: from this fact he drew a lesson for his own work. The deliberate choice of Poussin for his initiation into the art of the old masters vouches for the high aspirations of the young painter, and the myth of Narcissus taught him something of the spells and perils of the creative temptation and its unfathomable enigma. All poets, according to Schlegel, are emulators of Narcissus; and Leon Battista Alberti, in his treatise on painting, saw in Narcissus, the beautiful boy gazing into the waters of a spring at his own features, the inventor of painting.

The following summer Balthus set off on the then ritual journey to Italy, well prepared by the reading of Dante and the *Golden Legend*. To Florence first, where he lived in a terraced room overlooking the Piazza Santa Croce. He lingered long in the Carmine church, in the chapel frescoed by Masaccio, where he also appreciated the work of Masaccio's partner Masolino; and later, on the way home, he stopped at Castiglione d'Olona, near Como, to see Masolino's splendid frescoes there, with their Cézannesque inflexions. From Florence he went on to Arezzo, the main goal of his Italian pilgrimage. He took lodgings in a private house, spoke the pure Italian of the region, mingled in the daily life of this old Tuscan hilltown, standing amidst vineyards and olive groves. One cannot overstress the importance of this first visit to Arezzo, so intensely experienced in the rapture of youth and the ardour of his nature. His emotion was beyond the pitch of expectation when he first entered the church of San Francesco, crossed the long nave whose light and smell he has never forgotten, and reached the frescoed walls of the choir where, in the ether of a picture space unaffected by gravitation, there glows an unseen sun which casts no shadows. He made six enraptured copies in this shrine of Renaissance painting where, as it seemed to him, the glory of the visible world was rendered in its divine essence. The local train that took him at daybreak from Arezzo to Borgo San Sepolcro, the native town of Piero della Francesca, moves at times through the very landscape of the Arezzo paintings. The town museum at Borgo San Sepolcro contains one of the grandest of paintings, the supernatural

Resurrection, which he also copied, and in doing so noticed a detail overlooked by scholars: the conjuring away of the soldier's legs in the foreground. In the Palazzo Pubblico at Siena, in front of the wall frescoed by Simone Martini with the dreams of chivalry and the saga of the conquering condottiere, he met a Chinese student fascinated by the undeniable connections between the painting of his own country and that of the Tuscan Trecento. Chinese painters too, he told Balthus, have represented lunar landscapes very similar to the hill country around Siena depicted in the frescoes they were looking at together. There is then, over and above the historical periods and geographical areas, a universal and permanent convergence of forms on which mankind bases its principle of harmony and great artists their imperious classicism. Nothing better evokes the Olympia pediments, the Romanesque portals or Buddhist statuary than the columnar rhythm that Piero imposes on his trees and his processions of figures.

Balthus performed his military service with the French army in Morocco. Memories of it floated to the surface in a curious picture of 1949, *The Spahi and His Horse*, a title which would be more apt if reversed, as "The Horse and His Spahi," for the slender figure of the soldier is dwarfed by the commanding, archetypal animal with its bony, quizzical head. During his actual service in North Africa, he did no painting but steeped himself in the primitive beauty and grandeur of a country which had already cast its spell over Delacroix and Matisse. His understanding of the Moslem world was made easier by his familiarity ever since childhood with *The Thousand and One Nights*, which he read in the unequalled French translation by Dr Mardrus, whom he knew. Some tours of duty in southern Morocco opened his eyes to the majesty of the desert. The old Moorish city of Fez reminded him forcibly, in its colours and aspect, of the medieval city of Arezzo as depicted in Piero's frescoes.

While in art he looked to Italy, in literature he looked to England, a country in which he has always felt at home, being familiar with the English language, English manners, English writers. His closest friend during his early days in Paris was the poet and anglicist Pierre Leyris, who has made the classic French translations of Blake and Lewis Carroll. Among his ancestors was a Scottish lady connected with the family of Byron, that intrepid and self-reliant hero-figure who haunted him as an incarnation of the aristocratic, freedom-loving spirit. He was familiar with the Yorkshire moors long before he illustrated *Wuthering Heights* in 1933, a novel unique in its passionate intensity, its haunting grimness, its grey melancholy. The drawings for *Wuthering Heights,* whose incisive penmanship is lit up with something of the book's flame and storm-flashes, have a place apart in his work and provided the inspiration for several paintings. Significantly enough, the series of drawings breaks off at a point about halfway through the book; it carries on, that is, only so long as the world of Heathcliff and Catherine Earnshaw is that of childhood and adolescence. In these drawings Balthus clearly identifies himself with Heathcliff, the wilful outsider unamenable to morality and society, in his vengeful satanism and headlong transgressions–an exemplary creation and an undying presence on the absolute level of art and human destiny. A projected edition of the Brontë novel with Balthus' drawings came to nothing, but they were published in *Minotaure* in 1935: they offer a rare and compelling example of symbiosis between text and picture.

In 1934 he had his first one-man show at the Galerie Pierre in Paris, then one of the focal points of Surrealism; hence the persistent misunderstanding about his initial allegiance. It attracted the attention of clear-sighted painters and poets like Antonin Artaud, who in his review at once pointed out the essential characteristics of this art: organic realism, close knowledge of forms and lights, a power of creating sphinx-figures, and a Davidian technique in the service of a modern sensibility; and indeed the physical resemblance between Balthus and David was so

striking that it oriented Artaud's theory of the double. He saw in the young painter the artist of distinction predestined to regain control, *starting from visual appearances,* of the broken or tangled golden threads of beauty. In 1935, having noticed the colourful costumes and dark woodland sets which Balthus had designed for Jules Supervielle's French adaptation of *As You Like It,* Artaud enlisted the collaboration of Balthus in his own adaptation of Shelley's *The Cenci.* Another poet and friend of Balthus, Pierre-Jean Jouve, reviewed the performance in the *Nouvelle Revue Française,* emphasizing the painter's contribution: "For *The Cenci*

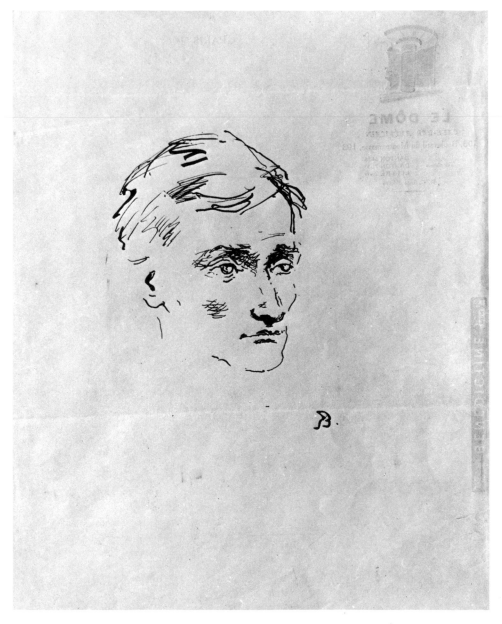

Antonin Artaud.
1935. (9 $^1/_2$ × 8 $^1/_8$ in.)

Balthus has invented, designed, constructed a prodigious space, a decor at once inward, symbolic and Italian, in which everything joins up with an extreme simplicity and force." Balthus' fondness for the theatre, stimulated by his friendship with actors and producers, and the intelligence and scrupulous care of his work in this field are by no means foreign to his preoccupations as a painter, for painting and the performing arts have always been interdependent and constantly interacting on each other. During the rehearsals for *The Cenci,* he drew on a table at the Café du Dôme the pure, intense face of Antonin Artaud, before it was ravaged by illness. This portrait of a transparent, almost mediumistic exactitude was reproduced in May 1935 in the second issue of the monthly *La Bête noire* edited by Tériade and Maurice Raynal. After the "success on the absolute plane" but failure on the earthly one of *The Cenci,* Artaud made a journey to Mexico and in June 1936 he published in the Mexican paper *El Nacional* an article in Spanish on the younger French painters and their attitude towards tradition: it remains a document of paramount importance on Balthus. Rilke, Jouve, Artaud: such was the constellation of poets which rose over the beginnings of the artist's career.

His earliest achievement, the picture with which this set of plates opens and the one on which attention was focused at the Galerie Pierre exhibition, is the second version of *The Street,* painted in 1933 and acquired by the American collector and museum director James Thrall Soby; it was thanks to him that the name of Balthus became known to a circle of art lovers in the United States even before the revelation that came in 1938 with his one-man show at the Pierre Matisse Gallery in New York. *The Street* inaugurates the series of larger figure compositions which stand out as landmarks in his work. It is a recasting, a broadening, above all a transmutation of the first version executed before he was posted to Morocco, by way of conclusion to a group of Paris townscapes—views of the Seine embankments from the Pont-Neuf, of the Jardins du Luxembourg with children playing round the

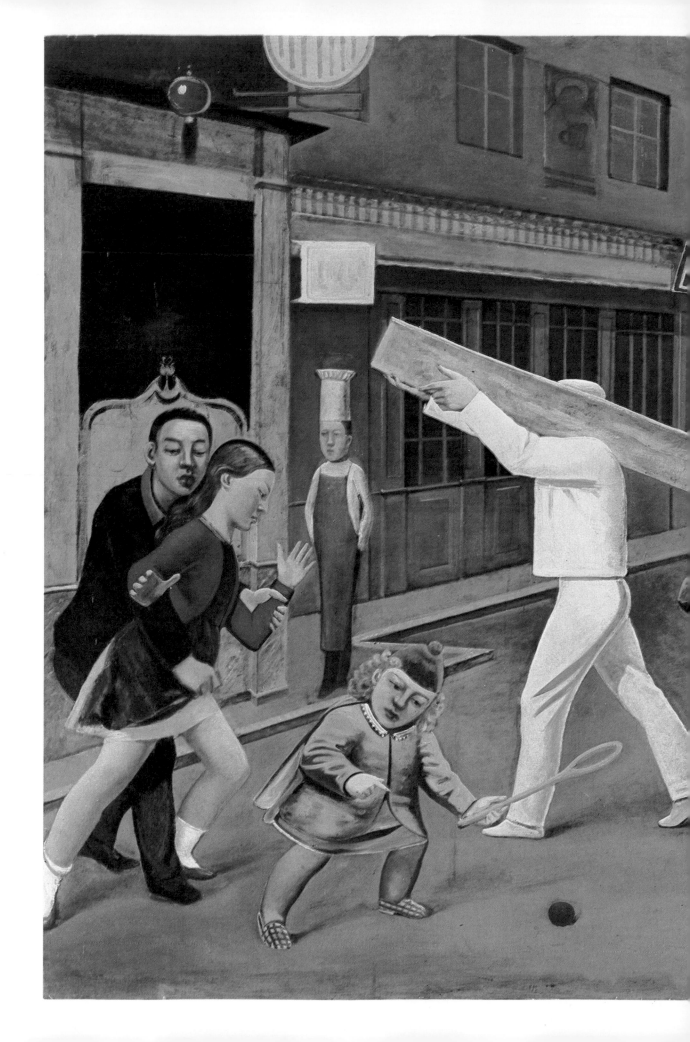

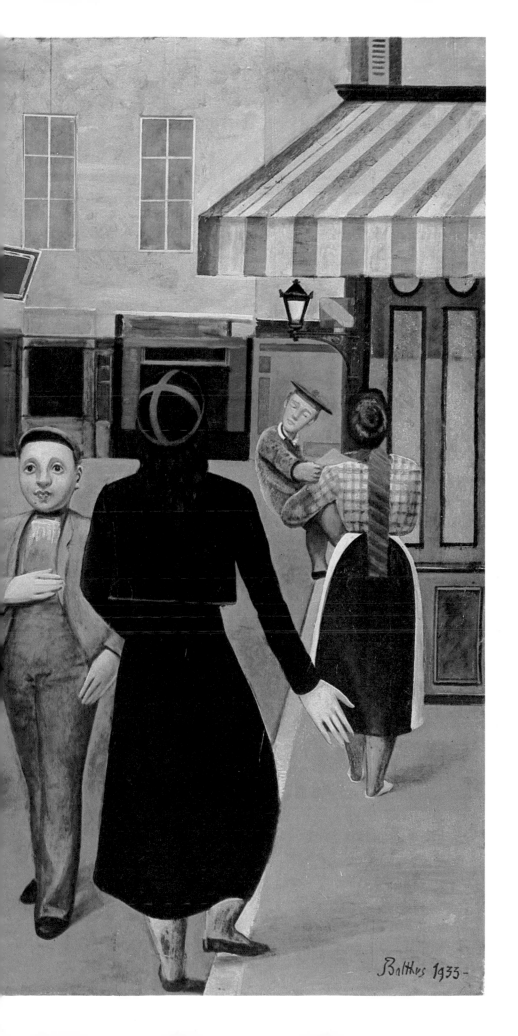

The Street.
1933. (76 × 94 ¹/₄ in.)

ornamental lake, of the Place de l'Odéon and its neo-classical layout. For all the firmness of the brushwork and the presence of forms and types that point to his forthcoming style, these trial pieces of his early youth still depend, for their handling and colour, on the impressionist way of seeing, and, for the layout and the pungency of the notations, on Nabi intimism as so delightfully transferred by Bonnard and Vuillard to their pictures of Paris streets and gardens.

The two versions of *The Street* were separated by his period of military service. Between them occurred a decisive crystallization, by way of several changes and readjustments at different levels. The limpid sunlight of Morocco dispelled the atmospheric veil and its fluctuations of colour; and the static prism of Seurat and Piero della Francesca took the place of Bonnard's ever-shifting kaleidoscope. These two changes jointly effected a new regulation of space, light and figures. Among the new friends he made in the mid-1930s were Julien Green and Aldous Huxley, who sought him out in his Paris studio in the Rue de Furstenberg, next door to the last studio occupied by Delacroix, the painter of genius and man of parts to whom he is akin in his culture and demeanour, his instincts and tastes, and whose inexhaustible *Journal,* so packed with thought and experience, is one of his favourite books. Crossing the quiet, provincial square in the middle of the Rue de Furstenberg, where the memory of Delacroix still seems so vivid, and turning left in front of the buildings of the former abbey of Saint-Germain-des-Prés, one reaches the short Rue Bourbon-le-Château crossed at very nearly right angles by the Rue de Buci. This is the location of the picture, in a setting of classical French architecture of simple and accurate proportions, with Paris shop-fronts, shop-signs, old-fashioned street-lamps and a bright façade with sharply designed windows as a background. The street corner on the right, with the lamp-post and striped awning, was taken over from another street; a liberty which the old view-painters often took without qualms, but one that the later Balthus would no longer permit himself to take. In this townscape,

thus delimited in the naïve manner of the "inn signs" and "fair-booth backcloths" lovingly described by Rimbaud and in the skilled manner of the Quattrocento masters for whom the sights of the street were also the theatre of painting, a strange pantomime is being enacted by nine figures who without meeting cross the space they rhythmically occupy and are suddenly frozen in their mechanical gestures. Camus noticed this power of magic fixedness peculiar to the old masters and in a singular degree to Balthus, who gives us the impression "of gazing through glass at people petrified by some kind of enchantment, not for ever, but for a split second, after which they will resume their movements." Nine in all countries is the perfect figure of measurement in space and of restarting in time. The white-clad carpenter carrying a beam as golden-hued as the mystic wood is the axis of pure form and auburn light around which gravitate the other figures, a prey to their phantasms or sunk in their dreams: the pair of schoolboys caught at their little game; the cataleptic baker under his big white cap; the dreamy girl chasing a red ball that punctuates the grey street; the workman with a cap whose firm step and strange face come as a surprise; the two women in black, seen from behind, one with her feet jutting out on the sidewalk, the other holding her sleeping child in her arms like a puppet. "Each of us," says Ritter, the master of Novalis, "has within him a sleepwalker of which he is the magnetizer." *The Street* closes one period and opens another. In it, avoiding academic pitfalls and oneiric subterfuges, Balthus succeeded in combining forces and forms, dream and reality, objective acceptance and inner trance, emblematic rigour and its oddities.

Balthus is sensitive to his surroundings, and the tone or mood of his painting depends on them. The various lodgings on which he has left his mark reveal the nature of the man, his love of an ordered, even severe arrangement and styling, such as best retain the imprint of the past. In 1936, leaving the Rue de Furstenberg and Saint-Germain-des-Prés, he moved to a different part of the same quarter, the Cour de Rohan, a quiet enclave of old town-houses backed against the medieval ramparts

of Philippe Auguste and built over the remnants of the old palace of the Archbishops of Rouen (hence the name, Rohan being in this case a corruption of Rouen), which Henri II had restored for his mistress Diane de Poitiers. A fascinating corner of Paris, with an antiquated charm of its own. The large, lofty, raftered studio occupied by Balthus had a monkish austerity about it, except for one unusual feature: the stately Renaissance bed with a gorgeous Persian bedspread, half-hidden in an alcove. The studio windows overlooked the third inner courtyard, which opens into a back-street called Rue du Jardinet–a reminder of the gardens once to be found in this neighbourhood. A picture of 1949–1952, *The Window*, with its governing pattern of uprights, conveys something of the roominess of the studio and the creative tension reigning there, as impressed on the still life in the corner. One feels the pulsation of light both inside and outside, the pollen floating in the air over the courtyard, the refraction of light on the opposite house-front, with its ambered and silvery walls, its calm and gaping casement windows. Only a few chosen friends, some of whom sat for him here for months on end, knew the way to this sequestered and austere retreat.

Balthus, at that time, painted a large number of portraits, both of single figures and groups of figures. Taken as a whole, this gallery of portraits will leave a memorable and socially varied record of our time. The most appealing of them is that of a girl, discreetly entitled *The White Skirt*, her hair falling loose, her bodice open in front, her hands hanging slackly from the armchair, the folds of her skirt harmonizing with those of the curtain, the abandoned pose of the figure contrasting with the controlled handling of the paints. The most impressive are those of the *Vicomtesse Marie-Laure de Noailles*, starkly deprived of fashionable trappings, and of the painters Derain and Miró; these last two are in the Museum of Modern Art, New York. They are full-length portraits, unsparingly frontal: as such they render the face without its mask and fix the identity over and above the likeness. These are unexpected successes in a period when the portrait had ceased to flourish, when the human being,

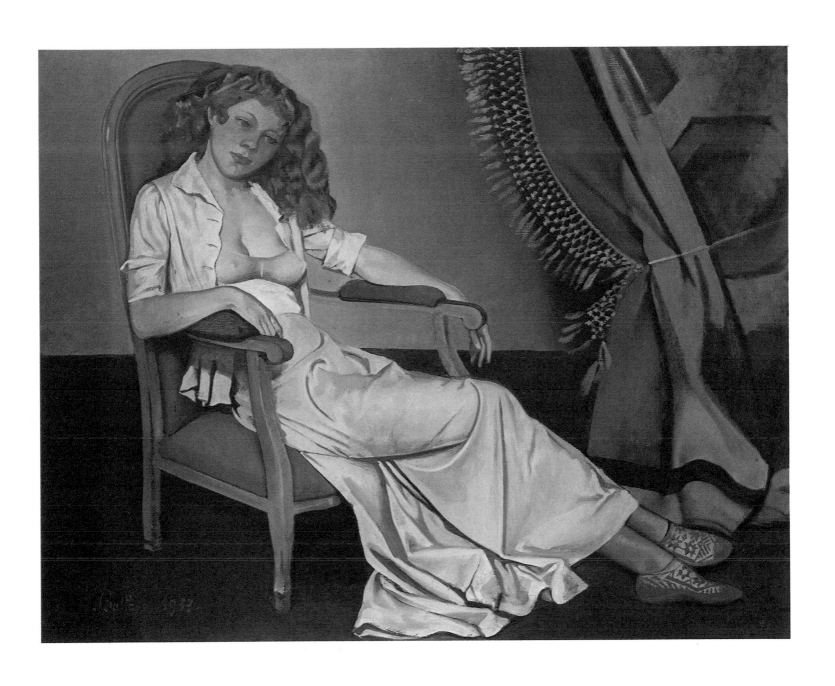

The White Skirt.
1936-1937. (51 $\frac{1}{4}$ × 63 $\frac{3}{4}$ in.)

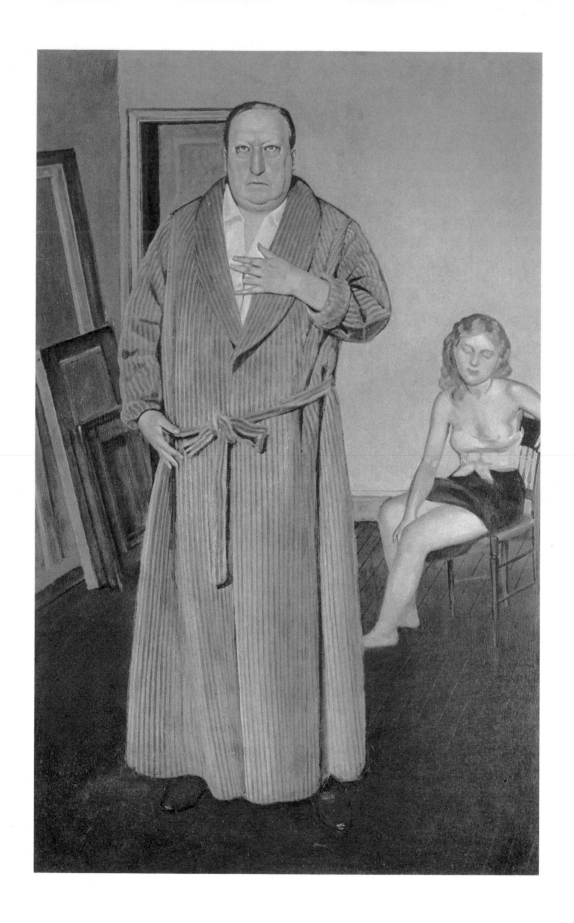

André Derain.
1936. (44 ³/₈ × 28 ¹/₂ in.) Collection, The Museum of Modern Art, New York.
Acquired through the Lillie P. Bliss Bequest.

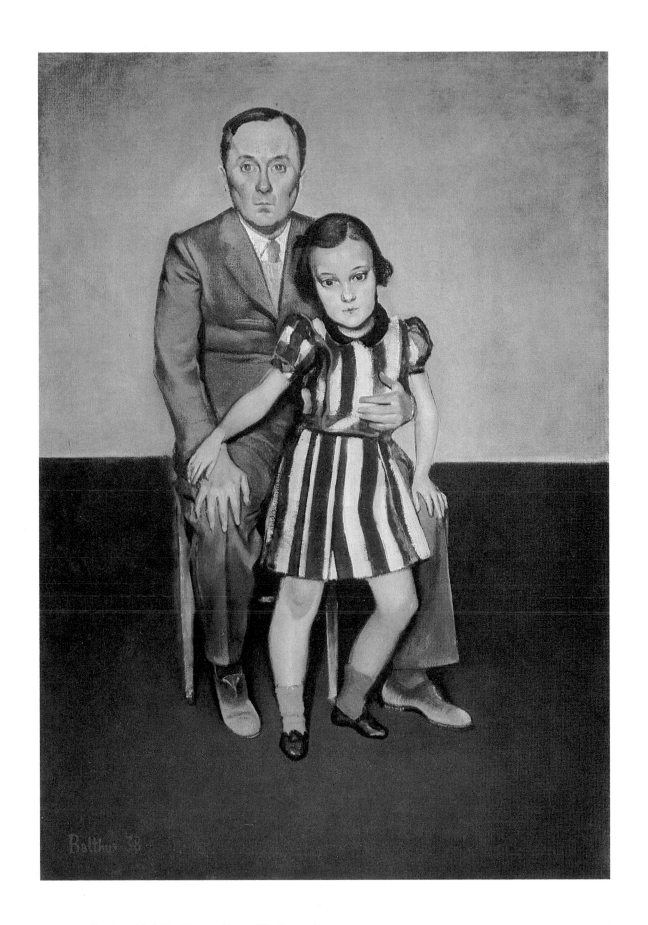

Joan Miró and His Daughter Dolores.
1937-1938. (51 ¹/₄ × 35 in.) Collection, The Museum of Modern Art, New York.
Abby Aldrich Rockefeller Fund.

23

apparently time-worn, was no longer an eternal emblem and saw his oneness destroyed by the indiscriminate analysis of phenomena and impulses. Balthus went back to the magic origin of the human effigy, to its function as a double and a celebration. "In each of his portraits," wrote Antonin Artaud, "there is this principle of synthesis which relates it to the old Chinese calligraphy and to certain pictures of the primitives." The primitive way of seeing, indifferent to psychology and capable of probing the depths, has maintained itself in folk art, especially in the Protestant countries of Europe, where the Reformation had the effect of sharpening the edges of individuality. In the Historical Museum in Berne, so rich in unfamiliar treasures, Balthus spent a whole summer copying some of the portraits, so truthful and so vividly alive, painted at the end of the eighteenth century by the Lucerne artist J. Reinhardt, a naïve follower of Cranach, Holbein and the brothers Le Nain; these are portraits painted to order, in the costume of the sitter's native canton, valuable for the documentary record they provide, but also revealing a depth and force of human insight which has gone unnoticed. The art of Balthus oscillates between knowingness and innocence, two qualities which for centuries went together easily to their mutual enhancement. Standing between the tokens of his profession, the canvases stacked against the wall and the tender charms of his fair-haired model, André Derain in his red and gold striped dressing gown presents his burly figure to us with the confident majesty of a Roman emperor or an Oriental wizard in possession of many secrets. "We have to drudge today," Derain used to say, "in order to regain the secrets we have lost." The best friend of Balthus, both as an artist and a man, was and remained the painter and sculptor Alberto Giacometti (1901–1966), who like him repudiated surrealism and abstraction in order to follow up the path opened by Cézanne. The fundamental difference between them lay in their execution: Giacometti, possessed as he was by his graphic frenzy, pursued a sketch-like style, perpetually unfinished; Balthus, enamoured of pictorial harmony, aimed at a finished style, stable and timeless. Among the many points that brought them together was their common

admiration for Derain, a giant flying in the face of current trends: they admired the ripe wisdom of the man, his humour and independent spirit, his spontaneous gifts and prodigious knowledge, his aesthetic of natural vision and continuity (which required more courage than the fashionable aesthetic of rupture). Balthus learned much from his long friendship with Derain, benefited much by the confidence shown him by an elder of that calibre, to whom in return he paid tribute with a monumental portrait. "The true portraits," wrote Delacroix, "are those one does of one's contemporaries. It is a pleasure for us to see them on canvas just as we meet them in our dealings with them, even if they happen to be famous people. Indeed, it is in the case of these latter that the complete truthfulness of a portrait offers most attraction for us."

How different is the portrait of Miró! Small, shy, silent, a man of unfailing kindness and winning ways, with candid, wondering eyes, Miró both in temperament and artistic orientation, is the very reverse of Derain, but like him well aware of the powers of Balthus, to whom he granted an unlimited number of sittings. His portrait is that of the whole man, inner and outer, recording the smallest details of his neat person, down to the smart suede shoes. Seated in the middle of a room divided by the meeting line of floor and wall into two equal zones of light and shade, he is utterly motionless and gazing straight at the painter holds tenderly against him his eight-year-old daughter Dolores, who is fidgety and eager to escape. The delicate positioning of the feet, the hands of father and daughter side by side on the father's knee, the counterpoint of the two bodies, one straight, the other flexed, the two faces with their family likeness: it is all a marvel of sensitive response and pictorial accuracy. Looking intently at this double portrait, this icon-like image so forcible in its exactitude, one realizes that its formal design is that of a Romanesque Virgin and Child: hence the resonance of its sacred overtones, inseparable from Spain.

Ludwig Tieck, the German romantic poet, wrote to a painter friend: "I would gladly dispense with action, passion, composition and all the rest if you could open to me with rosy keys the land of a child's mysterious thoughts." Balthus does just this: through the looking glass of the everyday world he sees and shows us the wonderland of childhood, but in doing so he cannot of course dispense with the essential laws of composition. To assert himself as a painter and to denote the autonomous character of his art, he needs to cast the activities, reveries and emotions of youth into the mould of geometry. A perfect example is a canvas of 1937, *The Children,* purchased from him in October 1941

"...because Cathy taught him what she learnt..."
1933. (10 ¹/₄ × 9 in.)

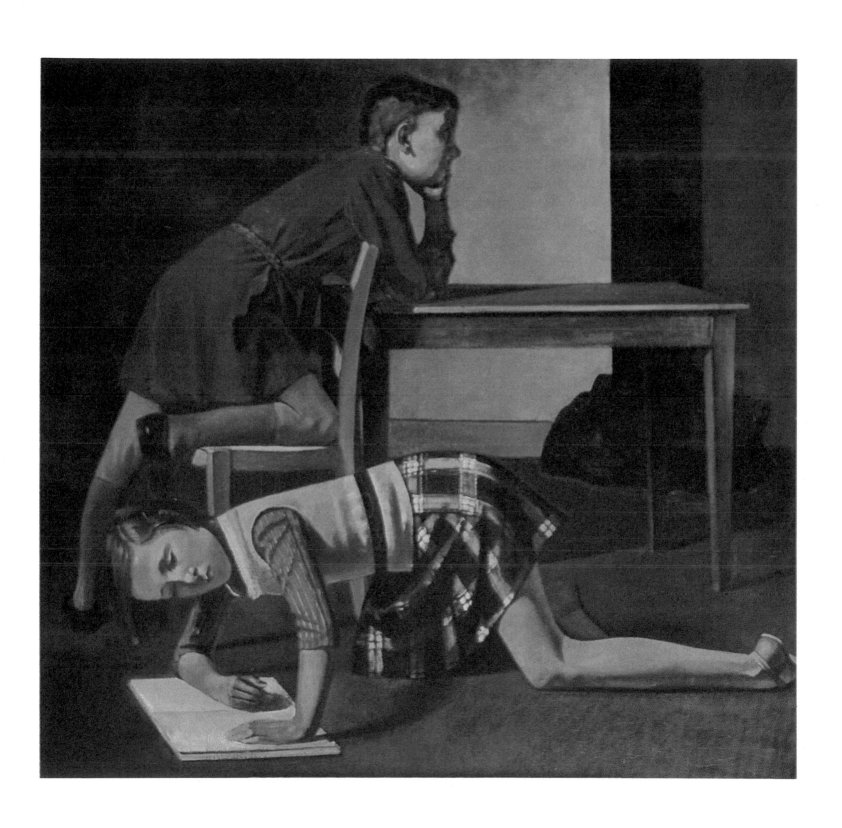

The Children.
1937. (49 $\frac{1}{4}$ × 51 $\frac{1}{4}$ in.) Pablo Picasso Donation, Louvre, Paris.

27

by Picasso (so that thanks to the Picasso Donation Balthus has had the honour of entering the Louvre in his lifetime). The models, Hubert and Thérèse, were the children of a neighbour; for Balthus, like Chardin who lived in this same quarter of Paris, painted the children he saw around him. The two figures are thus actual portraits; at the same time, interlocking with the deal table and straw-bottomed chair, they act as the formal elements of a strict and flawless eurhythmy. They are the ripened embodiment of the type-attitudes first worked out in the drawings for *Wuthering Heights* and developed and modified in subsequent pictures. The boy, his loose smock-frock tightly belted at the waist, his knee on the chair, his elbow on the table, is lost in a daydream, his profile set off by the clear patch of wall. His sister, her bare legs outstretched against the floor, her body arching forward, leans on her hands and slews her head round towards the large book lying open on the floor, her face being made visible in front view. The open book is the patch of light within a muted harmony of browns and bluish greys quickened by the white highlights running over the skirt. The black mass under the table is a bag of coal. The realm of childhood lies outside time, but this flawless canvas belongs to its time in its sharp conciseness and climate of seclusion. This girl Thérèse is the subject of at least three pictures of 1938: a half-length portrait of her against a neutral ground and two interiors showing her abandoned to her dreams or her perplexities. Reading is a major occupation of childhood, one way, through stories and tales, of evading the monotony of everyday life, of entering wonderland and going back to the age of myth. While Vermeer and the intimist painters of seventeenth-century Holland contrived to record the act of writing, of letter-writing as the vehicle of the feelings and the heart's innermost secrets, Balthus has recorded just as memorably the act of reading and its attendant mood of magic concentration. "There are it may be no days of our childhood that we have lived more fully than those which we fancied were left unlived, those which we spent with a favourite book" (Marcel Proust).

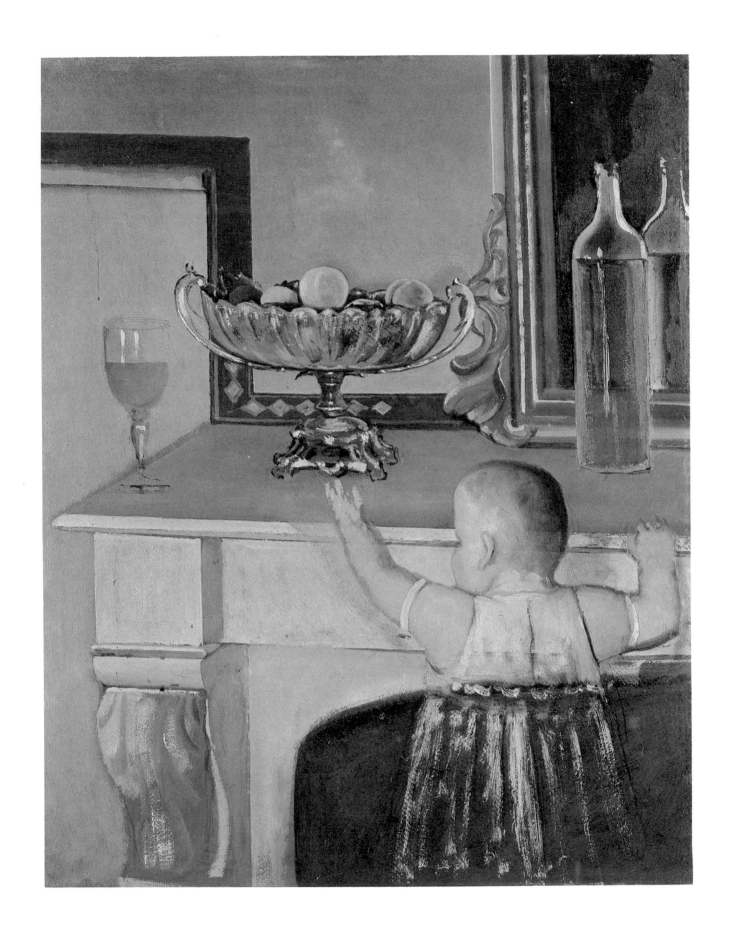

The Greedy Child.
1937-1938. (36 $\frac{1}{4}$ × 28 $\frac{3}{4}$ in.)

Balthus once began writing an essay (the manuscript is now lost) on the children's books of the nineteenth century, or rather on the three illustrated series of them which have left their mark on him and which, as he has acknowledged, are among the sources of his art: in France, the *images d'Epinal,* the sheets of coloured prints on didactic or moralizing themes made at Epinal in the Vosges; in England, the masterpieces of Lewis Carroll illustrated by John Tenniel, with Alice, her mirrors and her cats; in Germany, the stories of Dr Heinrich Hoffmann and in particular the famous *Struwwelpeter* ("shock-headed Peter"), an epitome of children's attitudes and antics in the face of parental authority, and an evocation of the typical burgher home. Balthus' elder brother, the writer Pierre Klossowski, who is of course thoroughly familiar with these formative elements and their continual emergence in a variety of shapes throughout the painter's work, has this to say: "Among the visual residues of these reminiscences, the structure of the fireplace, of that ensemble formed by the mirror, the mantelpiece and the hearth, strikes me as being one of those which have subsisted in the shape of patterns formed in the childish imagination: the mirror at once celestial and aquatic, symbol of the woman and mother; the fireplace, infernal and terrestrial, symbol of male violence..." This particular motif, however, only appears in Balthus when he actually has it before his eyes, in the old houses where he has lived; and he has taken it up not so much for its symbolic connotations as for its pictorial value and its architectonic solidity. It appears for the first time in 1938, during the summer holidays in Savoie, in the picture entitled *The Greedy Child*. The maid's baby clings with one hand to the chimney-piece and stretches out the other in desperation towards the inaccessible fruit-dish. The violence of his gesture gives a crimson flush to his garment and to the fireplace as well, the glow of the latter being re-echoed by the mirror with a Baroque frame reflecting the bottle and its effects of transparency. Balthus, so often presented as an artist obsessed with adolescent girls, when in fact his range is very wide, also has the knack of depicting infants who are the very embodiment of greed or wonder. Ten years later, he painted three

variations on the theme of *Goldfish,* of the small child raising his big round head and gaping in wonderment at the luminous bowl, seeking to fathom its shifting mystery, while on his chair sits the cat composedly, its features relaxed in a sardonic smile, for it knows the secrets that baffle the boy.

Though well able to hold his own, when he cared to go out, in the most brilliant circles of Parisian society, Balthus was always happy to return to the Swiss landscapes of his childhood. There he painted the extraordinary *Mountain,* emulating Courbet and using live models posed in the open air in actual places. This huge picture (c. 8 × 12 ft), which in view of the difficulties faced and overcome may be taken as the test and proof of the young artist's mastery, was begun in 1935, finished in 1937 and reworked in 1939. The setting, only slightly altered, is an accurate rendering of the actual spot, one the most grandiose viewpoints in the Swiss Alps: the ridge of the Niederhorn in the Bernese Oberland, at an altitude of 2,000 metres, overlooking the valley of the Justistal, one of the high Alpine pastures to which the flocks migrate from the lowlands during the summer. In the distance one can see as far as the French Jura, some seventy miles away, while behind rises the sparkling snowclad peak of the Jungfrau. This is the classic excursion from the highland village of Beatenberg, where Balthus as a boy had had the revelation of Chinese painting and, for several summers, had led the rough, open life of his local companions. Hence the emotional tie that has brought him back periodically to this part of the Bernese Oberland. His personal background coalesces with the mythical background of these mountains and heightens the picture's charge of meaning. The light is not that of early morning, as usually supposed; these long shadows are those of afternoon, the light coming from the left and following the transversal edge of the cleft where a diminutive file of seven figures is spaced out. The sum of four, the number of earth, and three, the number of heaven, the figure seven is a universal symbol of cosmic plenitude and spiritual mutation. The lifesize figures of three

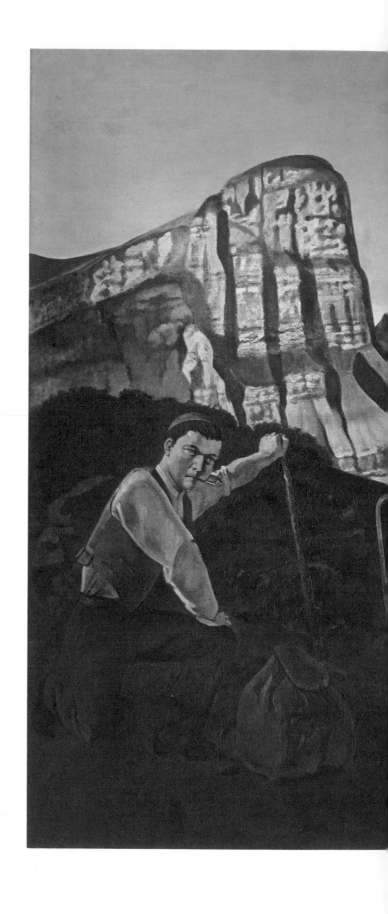

The Mountain.
1935-1937. (99 × 144 1/2 in.)

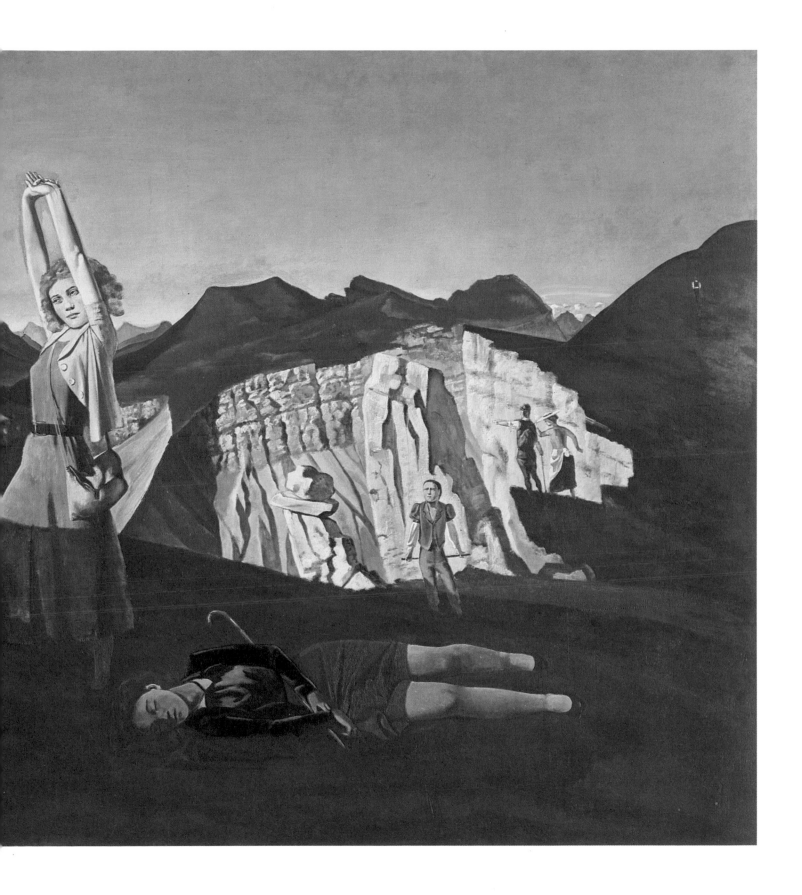

young people in the foreground, together with a fourth in the middle distance, form an answering group on this majestic terrain. Their walking sticks planted in the ground or held in the hand provide spatial references. The sturdy peasant lad kneeling beside his haversack, with a pipe in his mouth, is the spectral portrait of a childhood friend of Balthus carried off prematurely by appendicitis. He is placed in the zone of shadow, as is the dark-haired girl lying asleep on the ground, as if dead, in the pose of Poussin's *Narcissus*. The blonde girl emerges from the shadows with confident assurance and raises heavenwards her sunlit head and triumphant arms. The young man looking on from behind her, gazing intently at the scene, is another childhood friend of the painter's. He is wearing a shepherd's jacket with puffed sleeves. Its luminous vermilion forms with the dark garnet of the sleeping girl a harmony of red which rings out over the broad expanse of greens and blues, ochres and mauves. Further back are two local tourists, the woman holding on to her broad-brimmed, green and yellow hat of the Lake of Thun, as they gaze out over the crags below them. The tiny, pensive silhouette moving up the slope, towards the heights and the horizon beyond, is that of the painter himself, often present in his pictures, but always seen from behind.

Ever since Petrarch's account of his ascension of Mont Ventoux in 1336, the mountain has been the keynote of the modern landscape in the West, a bravura piece for writers but a challenge for painters unless they adopt a bird's-eye view and the screens of mist used by Chinese painters–the *sfumato* of Leonardo da Vinci. The highland scenery of the Engadine, in eastern Switzerland, has inspired some fine poems by Rilke and Pierre-Jean Jouve, and the Bernese Oberland has had its poets (Byron, for example), but few genuine painters, in spite of the reputation of the local master Ferdinand Hodler, with his stylized patterns of lines and colours. Balthus has taken a direct, a head-on approach to the Swiss mountains, to their crystalline limpidity and mighty bulk, without any atmospheric intermediary, just as he had seen them with the unclouded eyes of

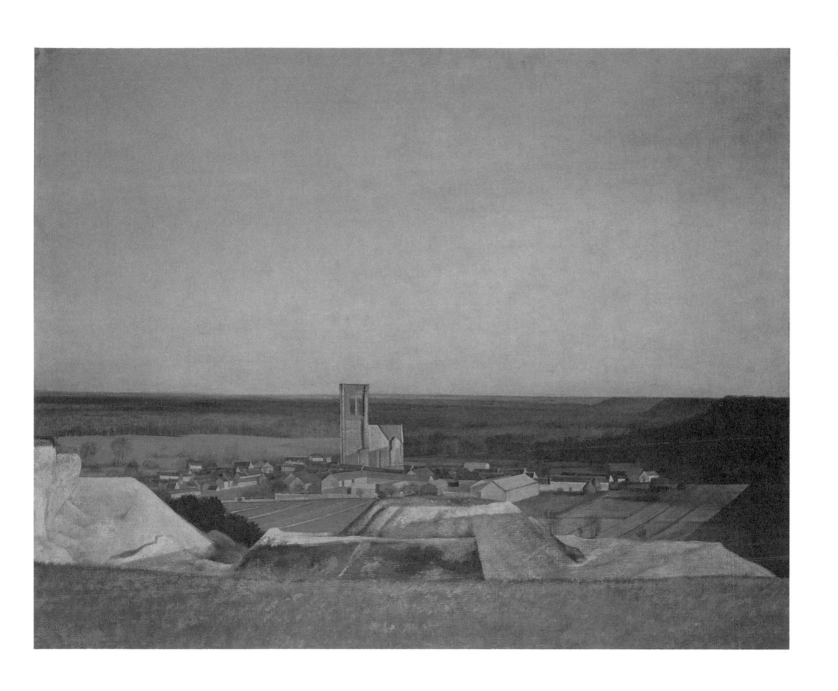

Larchant.
1939. (51 ¹/₄ × 63 ³/₄ in.)

childhood. During the execution of *The Mountain*, two artist friends followed his efforts, Derain and Giacometti. Giacometti, born in the foothills of the Grisons highlands and thoroughly at home in the Alps, marvelled at the relations between the male crag and the female crag which support the composition. Derain, to whom Balthus had presented his copy after Masaccio, did not hesitate to pronounce the name of Giotto. From the Primitives to Courbet and Cézanne, landscape painting offers many magnificent examples of rocks and crags, but those of Balthus do in fact, in their monumental simplification and vibrant intimacy, recall the rock-formations that punctuate the solemn story of Joachim in Giotto's Arena Chapel frescoes in Padua.

In spite of his predilection for the mountains, one of his purest masterpieces is a lowland landscape, the view of *Larchant*. On the edge of Fontainebleau Forest, on the road to Nemours, Larchant was in the Middle Ages a fortified town and place of pilgrimage. Today it is a forgotten village deep in the country, with, however, some fine vestiges of its historic past. As in Ruisdael's views of Haarlem, with a flat expanse of open country sweeping round the axis of the church tower, the sky occupies most of the canvas and gives the picture its luminous respiration. The quarries, roads and haystacks, the pattern of the fields, the clean-cut houses with red-tiled roofs, the woods and their autumnal tinge, the slopes with sandstone rocks, all go to organize planimetrically this vast silent space in the centre of which rises in ghostly eminence the tower of the St Mathurin church. In his fervent essay on Balthus, in which he emphasizes—possibly overemphasizes—the necessary conflict between the artist's inner tumult and his will to objectivization, Yves Bonnefoy singles out this moment of grace and consent: "Beyond the road and in the peace of the ploughed fields, above the motionless and seemingly hushed village, the towering ruin of the cathedral is an affirmation at once heroic and calm, a token of unworldly timelessness. Here destiny is identified with a native plenitude. And in the scant colour of physical things and the simple earth patterns, the light here sets an

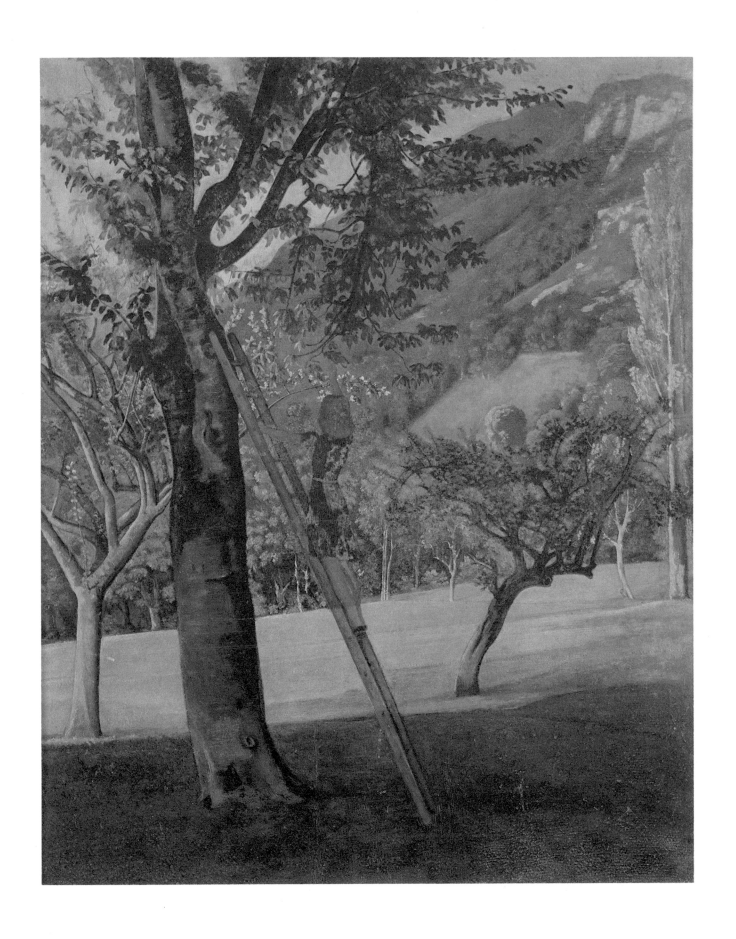

The Cherry Tree.
1942. (36 $\frac{1}{2}$ × 28 $\frac{3}{4}$ in.)

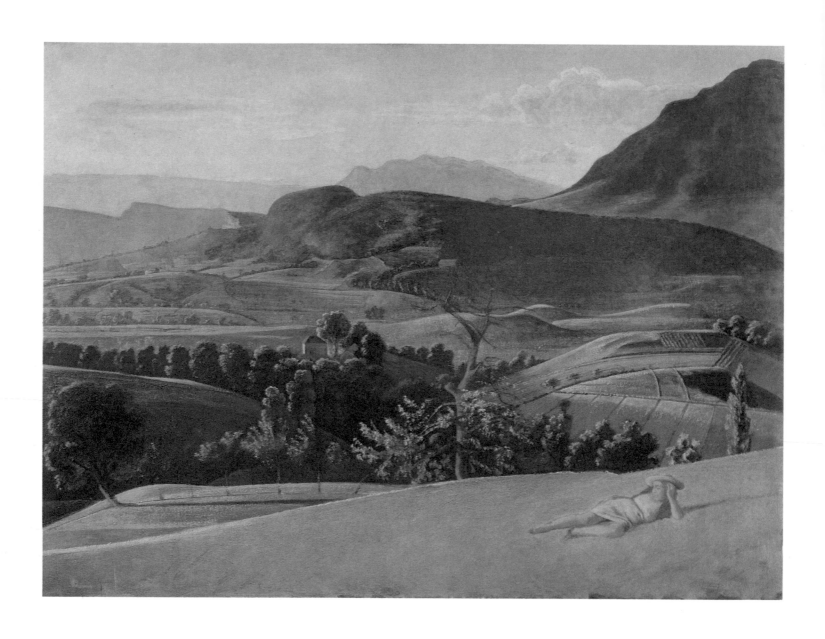

Landscape at Champrovent.
1942-1945. (38 $\frac{1}{2}$ × 51 $\frac{1}{4}$ in.)

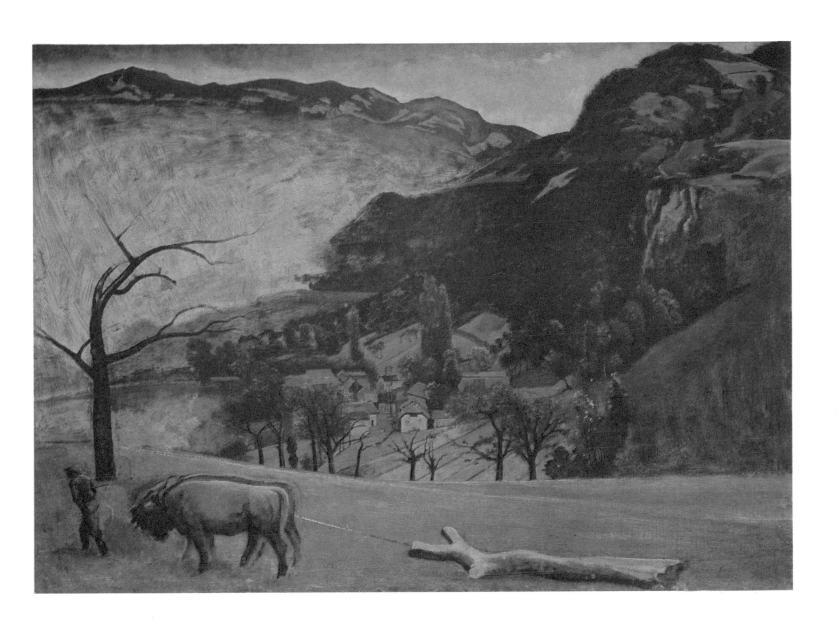

Landscape with Oxen.
1942. (28 $^3/_8$ × 39 $^3/_8$ in.)

absolute limit to all depth of experience, its clarity is such that there can now be nothing more beyond or beneath it. Never has the face of what is been more faithfully recorded, nor could any work better than this union of a place and a light suggest what healing power may come from seeing at its simplest, from an art beyond art, from the life within things."

After his war service in the French army and his demobilization in 1940, Balthus withdrew to Savoie, where he had already painted *The Greedy Child*. He lived on an upland plateau at Champrovent in one of the castle-farmsteads common in that remote, still unspoilt province known as Bugey, between the Rhone valley and the Lake of Bourget. The rude but noble old house suited his temperament and became imbued with his presence, and the landscape thereabouts composed itself readily into painting. There he painted *The Cherry Tree*. The ladder stands in the orchard in front of the house and a girl plucks the cherries from among the forked branches. Below, under the chestnut trees, runs the stream, and the nearby mountain raises its protective bulk against the light. The narrow patch of sky gleams through the boughs–their patterns a painter's delight–and its brightness casts a glow over this rural orchard. So flawless, so painstakingly realistic as it is, this work is yet evocative, with no metaphorical diversion, of the tree of life, of Jacob's ladder, of the Chinese theme of beauty beneath the tree, of the Japanese connotations of the cherry tree. Above all, though in a completely different atmospheric context, the girl on the ladder re-echoes a like figure, also on a ladder, also plucking fruit from a branch, in Poussin's *Autumn,* one of the sublime series of "Seasons" in the Louvre.

From about the same spot where he painted this *Cherry Tree,* Balthus set up his easel again and widening his angle of vision painted in two companion pictures the immense landscape lying before him. The right panel, *Landscape with Oxen,* is focused to the east on the cold dark slopes of Cat Mountain, at the foot of which, in a girdle of trees, nestles the red-

roofed village of Vernatel. A strange yoke of oxen in the foreground is being led homewards, drawing behind it a cross-shaped treetrunk, due to serve as a gallows, it may be, and memories of Bruegel come to mind. This picture was painted in the darkest days of the German occupation, and the dead black tree arching upwards beyond the plodding peasant and team deepens the impression of gloom. The left panel, *Landscape at Champrovent,* is a set-off: it opens to the west on blue distances and the sunny descents of grassy or wooded slopes, with solid manor-houses between the clumps of trees and blurred reaches saturated with lights and shadows under a bright summer sky. The peasant girl in red and green outstretched on the orange-coloured slope is Georgette, the farmer's daughter: a realistic transposition of a Giorgione nymph, she introduces the human element into this pure landscape so rich in Venetian overtones. In her *Pillow Sketches* a Japanese noble lady of the eleventh century, Sei Shonagon, notes as things worth painting the winter landscape, the summer landscape and the mountain village. These two companion pieces by Balthus are the landscape portrait of a beautiful, little-known region of France, which had gone undiscovered by the many painters who had come that way and worked for example in the neighbouring Dauphiné, like Jongkind, Corot, Courbet, Daubigny and Bonnard. The classic Chinese treatises on landscape, written by painters, not by aestheticians, like those of Tsung Ping (375–443) and the Sung master Kuo Hsi (eleventh century) who wrote when this art form was at its zenith, attribute to painting the almost miraculous power "to make the viewer feel as if he were really in the place depicted." Not one of Balthus' landscape paintings but awakens this felt response to nature; not one but gains in depth when the viewer has seen for himself the place whose spirit it so felicitously captures.

At Champrovent he painted not only landscapes but also interiors with children. One shows in its literal and yet compellingly mysterious aspect *The Living Room,* with its quadrangular space, its neat panelling and heavy bourgeois furniture, the piano, the pedestal table, the sofa, the

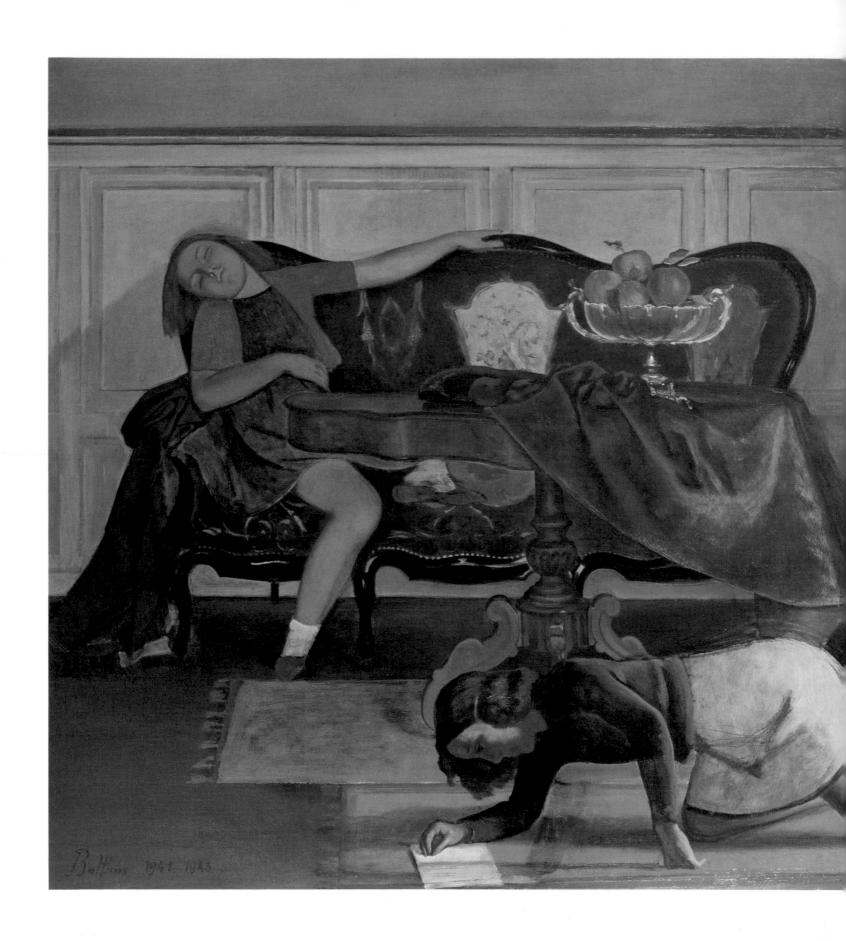

The Living Room.
1941-1943. (45 × 58 in.)
The Minneapolis Institute of Arts,
John R. Van Derlip and William Hood Dunwoody Fund.

43

fabrics strewn with some disarray over table and sofa. The same girl is shown twice in contrasting poses, one active, the other passive, one crouching over a book in the pose of Thérèse on the sand-and-sun coloured rug beside a grass-and-moon coloured rug, the other dozing on the sofa with her head thrown back. Pale greys and silky or velvety browns envelope the central accord of red and green, full-toned but restrained. Braque much admired the shapes and patterns of this composition, which preceded by a few months the one he painted at Varengeville on the same subject, during the summer of the Liberation, but without any human presence. To a second version, of like design and format, he added a white cat with closed eyes, a sharer in the dreams of the sleeping girl.

In 1943 he moved to Switzerland, first to Berne, then to Fribourg, a quiet old patrician town. There he painted the *Gottéron Landscape* and some intimate interiors, the best known being *The Golden Days*. Closed in by a rockface that is partly bare, partly wooded, the Gottéron ravine ends at the lower gates of the town of Fribourg. Balthus set up his easel at the foot of the torrent tumbling over trout-coloured boulders, and with the unruffled audacity of Courbet in front of the gorges and steeps of his native Jura (the *Gour de Conches* of 1864, for example), he faced his motif head-on, in all its compact and tactile mass. The hillock blocks off all but a strip of sky and lays bare its geological texture and patchy overgrowth. It is an autumn evening, and through its subdued phosphorescence the darkling figure of a woodcutter is homeward bound with his faggot on the winding path. Though scarcely visible, he is an indispensable reference mark, like the tiny human figures in the Chinese landscapes whose mental conception this picture of mountain and water shares. There come to mind the words of Mi Fei, the supreme connoisseur of the Sung period, describing the work of Fan K'uan (early eleventh century), whom he considered the greatest of Chinese painters and the best interpreter of the mountains in their rugged majesty: "His manner is lofty and powerful, the effect is one of sombre intensity, as if

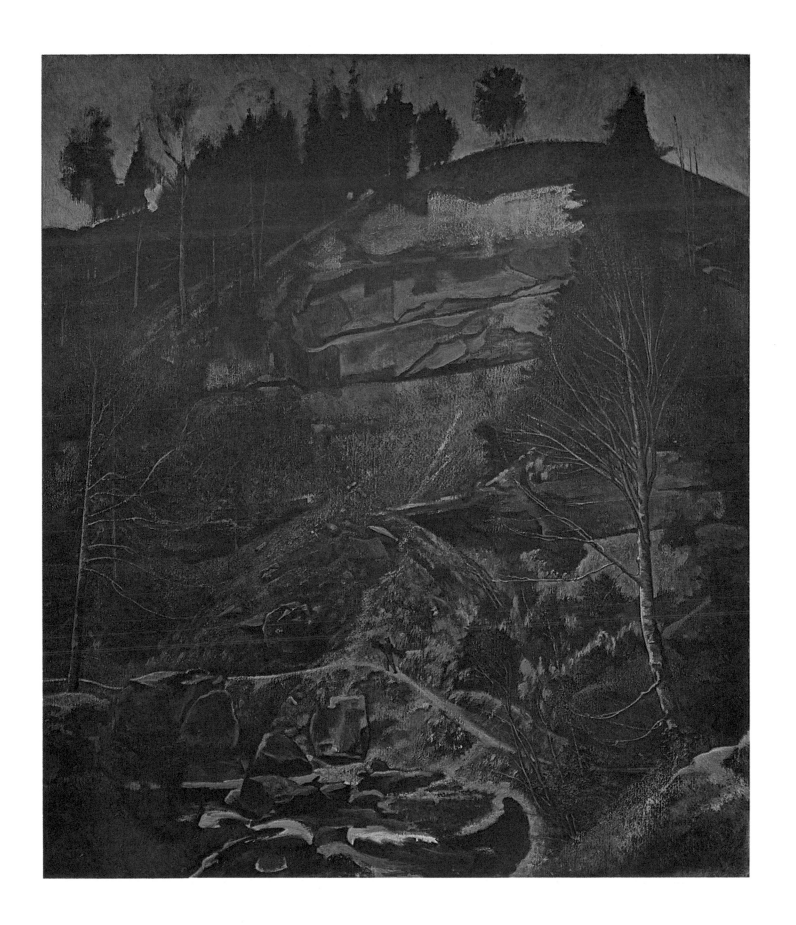

Gottéron Landscape.
1943. (45 $\frac{1}{4}$ × 39 $\frac{1}{4}$ in.)

wrapped in the darkness of night: there is no telling the earth from the stones and the mystery-laden face of things is of great beauty." This comment applies equally well to Balthus' *Gottéron Landscape,* wholly personal though it is and not a mere compound of Fan K'uan and Courbet; but the reference to these two very different masters gave him the opportunity of disengaging his own style and the truth of the motif. Great artists are well aware that they themselves are but one more link in an age-old venture which both transcends and sustains them; well aware that, through the achievements of their self-chosen or indeed (as Borges would have it) self-created precursors, they are drawing on an ancestral heritage, the common inexhaustible source in terms of which they shape their images and justify their emotions. The universal knowledge of art now made possible by the wealth of available books and reproductions goes hand in hand with the quest for innocence, which today lies not in naïve unknowing but in memory informed by knowledge. What Giuseppe Ungaretti has said of contemporary poets applies also to painters: "A poet of old-world civilization can go beyond memory only by force of memory itself, and for him innocence, the illusion of innocence, the illusion of a world restored to newness, can only be the fruit of memory, of memory informed by knowledge. The beauty of a sky, a leaf, a fountain, touches us because an age-old truth in which we believe emerges for us from the heart of the unexpected word that hymns it." The work of Balthus is packed with memories and quotations, but the game of detecting the influences he has absorbed, while it may amuse, leads nowhere, for he has remoulded them all in his own way with a firm hand, as Cézanne did when he set out to "revivify Poussin in contact with nature."

The composition known as *The Golden Days,* so transparent in its meaning, beautifully conveys its emotional power and high-wrought pictorial excellence. It takes us back to that inner room with a fireplace. The man seen from behind, stripped to the waist, who is stirring the fire with the virile ardour that Heathcliff put into stirring the immense

wood, peat and coal fires of Thrushcross Grange, is the painter himself, in his role of intrepid and accomplished alchemist. The sphinx-headed andiron is like a paradigm of the cat. The girl in the easychair, whose wavy hair reflects the lambent flames and the upsurge of desire, partakes of both Alice and of Cathy, Heathcliff's companion. She gazes at the enigma of her beauty in a looking glass of the same size as her face, which is shown without distortion in front and side view at once. A symbol of the moon, of woman, of amatory harmony, the mirror also reflects the sunlight outside and stands opposed, by its nature as captive water, to the energizing and sexual nature of the fire. On the mantelpiece is an ornamental, upright vase, and on the table by the window, through which daylight comes, is a plain, squat basin. The girl with her glowing body, whose forms are veiled by the stylized folds of skirt and bodice, is the meeting point between sunlight and firelight, between the yellow beams of one and the orange gleams of the other. The colour scheme rests on the continuous interpenetration of red and green—green thus signifying the Baudelairean paradise of young lovers. On its completion the picture was reproduced in the Paris review *Cahiers d'Art* (No. 20–21, 1945) with an essay by René Char concluding with these words: "The work of Balthus is speech in the treasury of silence. We all desire the caressing of that morning wasp whom the bees designate by the name of girl and who conceals in her bosom the key to Balthus."

After some months in Geneva, where (like Byron in 1816) he lived in the Villa Diodati above the lake, and frequented the circle of Albert Skira, the publisher in whose name and memory this book is issued, Balthus was back in Paris late in 1946. He fell in with his old friends and made two new ones, Malraux and Camus. He designed the sets and costumes for Camus's play *L'Etat de Siège,* staged by Jean-Louis Barrault, and for Ugo Betti's *L'Ile aux Chèvres,* featuring Alain Cuny. In 1950 he spent six months designing and personally executing the stage scenery for a production of Mozart's *Così fan tutte* at the music festival of Aix-en-Provence. Again the poet Pierre-Jean Jouve, as an art lover and opera

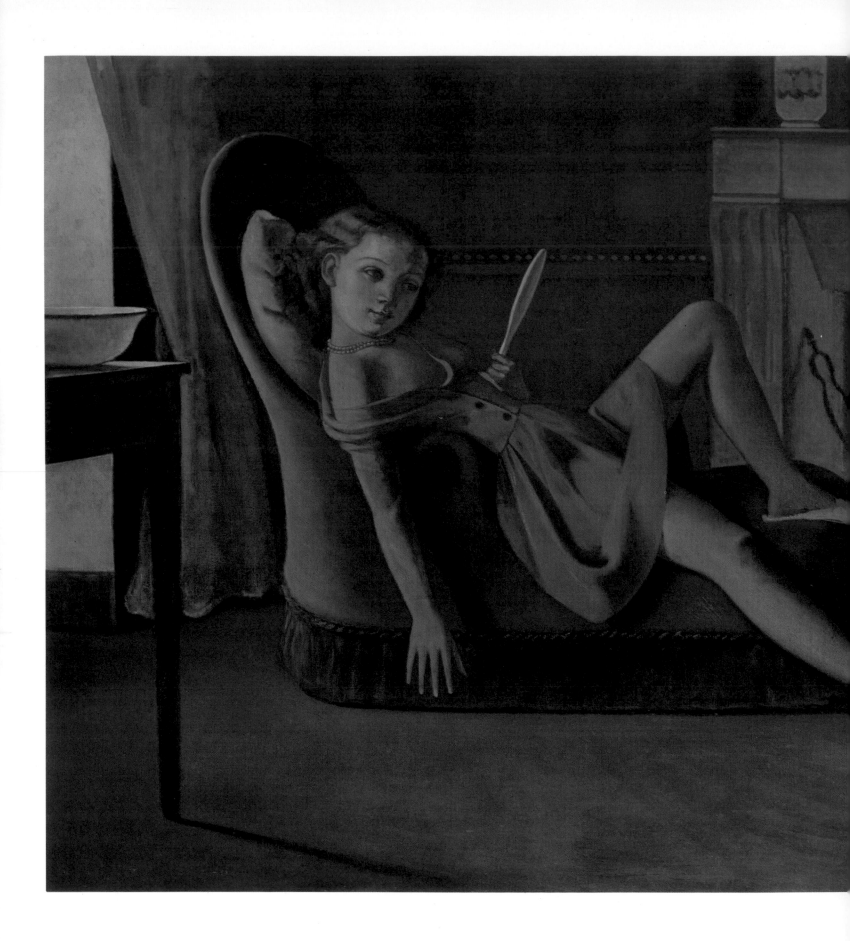

48

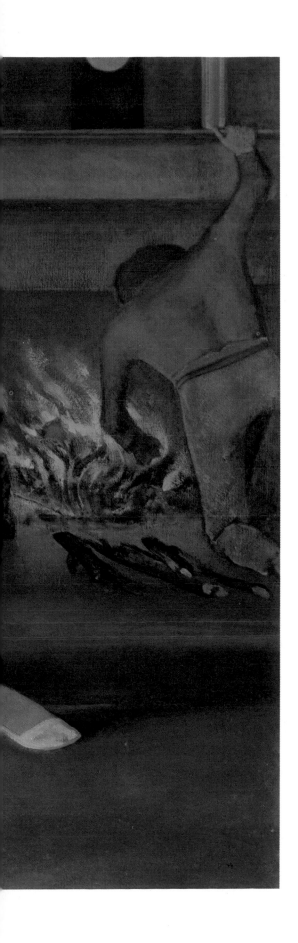

The Golden Days.
1944-1949. (58 $\frac{1}{4}$ × 78 $\frac{3}{4}$ in.)
Hirshhorn Museum
Smithsonian Institution, Washington, D.C.

fan, paid tribute to his work: "With no alteration of the conventional forms, everything takes on a glow of enchantment. In the underside of things lies the magic spell. To begin with, one meets again the principles of Balthus' painting, in which the reality of outward forms strongly expressed in line and colour cannot quite conceal the underlying dream of objects and beings, the unuttered but imperious depths, the world of a certain secrecy. But while his painting has an atmosphere of pronounced gravity, the sets for *Così fan tutte,* which have to envelope the flow of irony and sensuousness, are all in a key of great brilliance." Balthus, whose tastes in music are even more exacting than in painting, because the essence of music allows of no tampering with its laws, shares with Delacroix a reverence for Mozart. For him all painting is based on the harmony between cool and warm tones, unfolding in rising and descending sequences like the notes of that divine musician.

Several great painters, Courbet, Géricault, Chardin in his early days and Watteau in his final masterpiece, have consented to design shopsigns, yielding to the conventions of the genre. The picture called *The Méditerranée's Cat* was specially painted in 1949 for the seafood restaurant "La Méditerranée" in the Place de l'Odéon. Living in the neighbourhood, Balthus was one of the habitués of that well-remembered restaurant, whose clientele included so many writers, artists and stage-folk. The setting of the picture is a seaside terrace: there, with knife and fork poised for action, a lusty diner with the grinning mask of a cat is about to tuck in to the mullets which a fabulous rainbow is conveying straight from the sea into his plate. The distant sister of Courbet's *Woman in a Podoscaph* (1865), a pretty girl in a skiff, in the lee of the terrace, is pulling out to sea with a friendly wave of her hand. The lobster on a platter, standing on a packing case beside the diner, brings to mind the magnificent watercolours of crabs and crayfish painted by Dürer in Venice after a sight of the fish-market. Balthus' only seascape, this fanciful canvas so fine in its sunny simplicity embodies his memories of a stay with Picasso in the summer of 1947 at Golfe-Juan, on the French

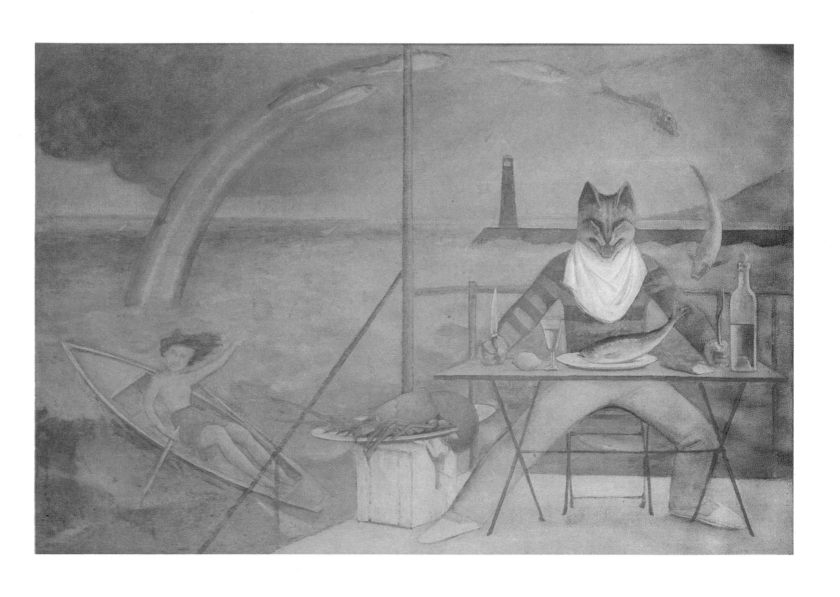

The Méditerranée's Cat.
1949. (50 × 72 ³/₄ in.)

Riviera. It is also a facetious, allegorical image of the artist himself, whose temperament is markedly feline. Balthus loves cats and in 1935 had painted a self-portrait inscribed in English "H.M. The King of the Cats."

After the war he returned several times to Italy, discovering and exploring Rome and Venice; his pre-war trip to Italy had been devoted entirely to Tuscany. In Rome he was the guest of the Caetani family, which also welcomed him to their medieval castle at Sermoneta, where in 1951 he painted the wonderful little *Italian Landscape,* a gem of a picture whose first owner was Albert Camus. Here, in his concern for accuracy, he harked back to the aerial, miniaturistic vision of the Quattrocento masters. The road to the village winds its way up the hillside as if traced out by the hand of a calligrapher. The network of brownish paths articulates the green and yellow movement of the hill and its flickering pattern of silvery olive-trees. Around the houses of dream-like proportions floats the faintly pinkish light of this *terra latina.*

Two monumental paintings, one an interior, the other a townscape, executed simultaneously from 1952 to 1954, are the major achievement of these Paris years. The lofty *Room* with its pure geometric volume actually represents his studio in the Cour de Rohan but is turned into his private stage for the play of light, into the receptacle of its incarnation. A metaphor for the godhead, light is the godhead of the painter, the medium of vision and at the same time the object of vision, inasmuch as forms exist or anyhow appear only when fused with its essence, quickened with its radiance. The flesh of woman is its triumph, and in the ardent penumbra of the bare-walled, bare-floored room the glorious nakedness of the girlish body aglow with sudden daylight brings about the miracle of painting: the magnetizing of light and the wizardry of space. But here, as once before with Manet's *Olympia,* even the canniest critics are apt to project into this splendid painting their own murky phantasms, to read sinister forebodings into the dwarfish figure opening

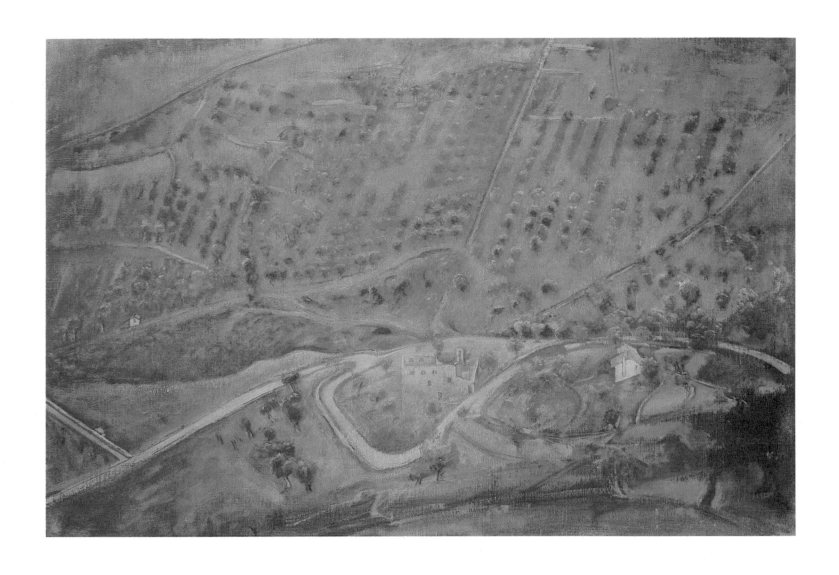

Italian Landscape.
1951. (23 ¹/₄ × 34 ¹/₄ in.)

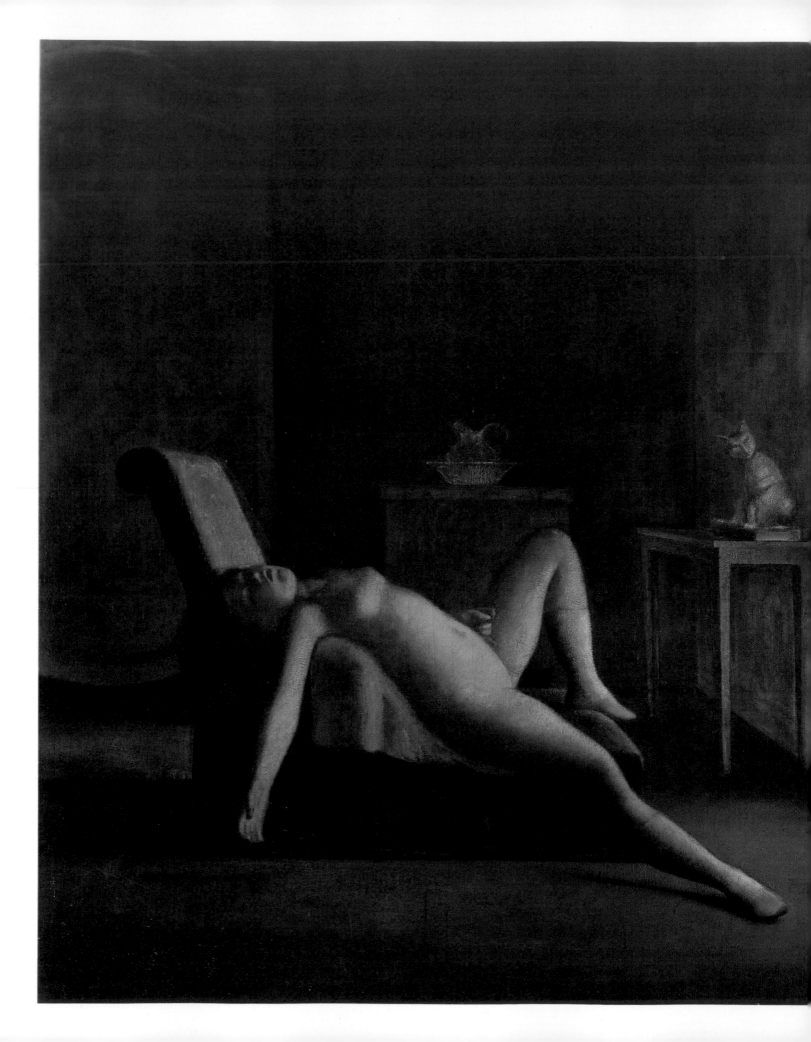

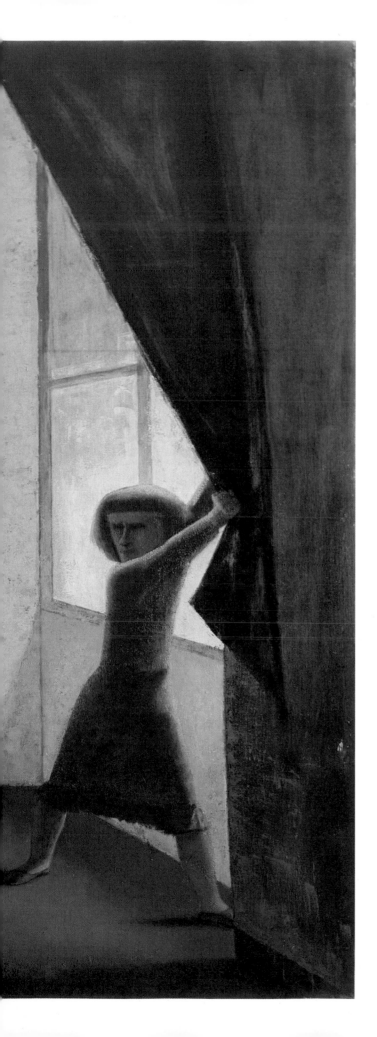

The Room.
1952-1954. (106 $\frac{1}{2}$ × 130 in.)

(or closing?) the curtain, to speculate on the outrage awaiting, or already perpetrated on, this would-be victim, with of course the perverse complicity of the watchful cat. The only answer to this sort of thing is that the business of painting is to reveal presences, not to weave plots. "No painting can tell a story, for none can render passing time," writes Octavio Paz, referring in fact to a Balthus picture. "Painting confronts us with definitive, unchanging, motionless realities. There is no picture, not even excepting those whose subject is real or supernatural events or those which give us the impression or sensation of movement, no picture in which anything *happens*. In a picture things are, they do not happen." While Octavio Paz was Mexican ambassador to India, Balthus called on him in Delhi, and to Balthus Octavio Paz dedicated one of his recent poems on light, of which this painting of *The Room* is an epiphany:

La luz entra en si misma y en ella se tiende,
es una piedra que respira y un caballo de lumbre,
la luz es una muchacha que se tiende
a los pies de la luz—un haz obscuro que clarea...

What about the cat in *The Room,* perched on the wizard's Book of Spells? Is this, one wonders, the bookish cat fond of reading Tasso's *Jerusalem Delivered* in "a musty edition for cats" which C.A. Cingria has inimitably described? This cat, anyhow, has just been licking his paws or coat, only to have his attention diverted by the sudden influx of daylight, as the curtain was suddenly drawn by the brazen little figure in green and yellow with sharp, triangular features posted in the pink and lilac embrasure of the large window. His resolute gesture and piercing glance impart to the ray of light its force of disclosure, its power of revelation. In handing over to us this treasure of nakedness, this feast for the eyes yielded up unreservedly in the surrender of sleep, the painter worthy of the name is not the indelicate interpreter of our own obsessions, but rather a perpetual hierophant. In a society closed to the sacred, Balthus, if he is to safeguard his capacity for wonder, must now

and then resort to the celestial display of humour, in subtle collusion with the cats he loves. The glowing focus of the composition, the sleeping nude with head thrown back in an aura of purple and emerald, with one leg arching upwards and hair and arm hanging down loosely, carries to its climax the cambered and abandoned pose taken previously by one of the girls in *The Living Room*. A pose of superb plastic invention in its sovereign sensuousness and unquestionably provocative but not erotic in the true sense, which implies obstacles and calculation, taboo and transgression. Of all the pictures of girls that he has painted, only one is deliberately erotic, and it is an early work: *The Guitar Lesson* of 1933. The pastor of a poor, multiracial neighbourhood of Los Angeles, the Reverend James L. McLane, a friend of Stravinsky's, was also an unreserved admirer of Balthus. By the time he died he owned three Balthus paintings, all three in what is considered Balthus' most characteristically equivocal vein, and these McLane set up almost as icons in his wooden parsonage and brought his congregation to share his admiration for their mysterious attraction and hieratic plenitude.

When, near the Odéon Métro station, after walking past the old houses in the Rue de l'Ancienne Comédie where Molière had his theatre and David his studio, one reaches the end of the street, just before the Carrefour de l'Odéon an archway opens up on the left and leads at once into that quiet byway of old Paris shops and houses which Balthus painted with literal accuracy, almost lifesize, in the picture known sometimes as *La Cour* and sometimes as *Le Passage du Commerce Saint-André* because it represents the intersection of these two back-streets. The Cour is the street in the foreground, running between the house-fronts aligned on either side like stage sets; at the back is the Passage du Commerce, a street of shopkeepers and tradesmen opened up in the eighteenth century between the Rue Saint-André-des-Arts and the Boulevard Saint-Germain. The long, low, shuttered shopfront, with the word REGISTRES inscribed above it, is the printing office where from 1789 to 1792 Marat printed his notorious paper *L'Ami du Peuple*.

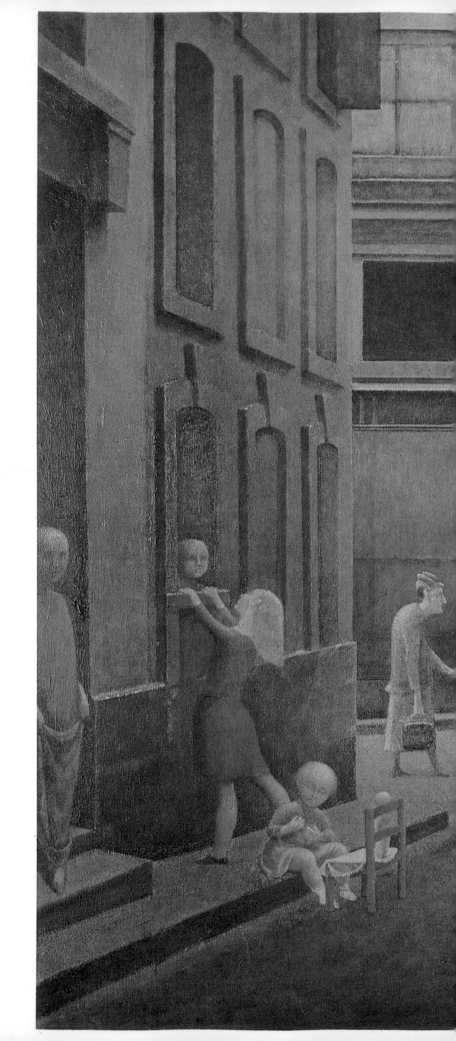

The Passage du
Commerce Saint-André.
1952-1954. (115 $\frac{1}{2}$ × 130 $\frac{1}{4}$ in.)

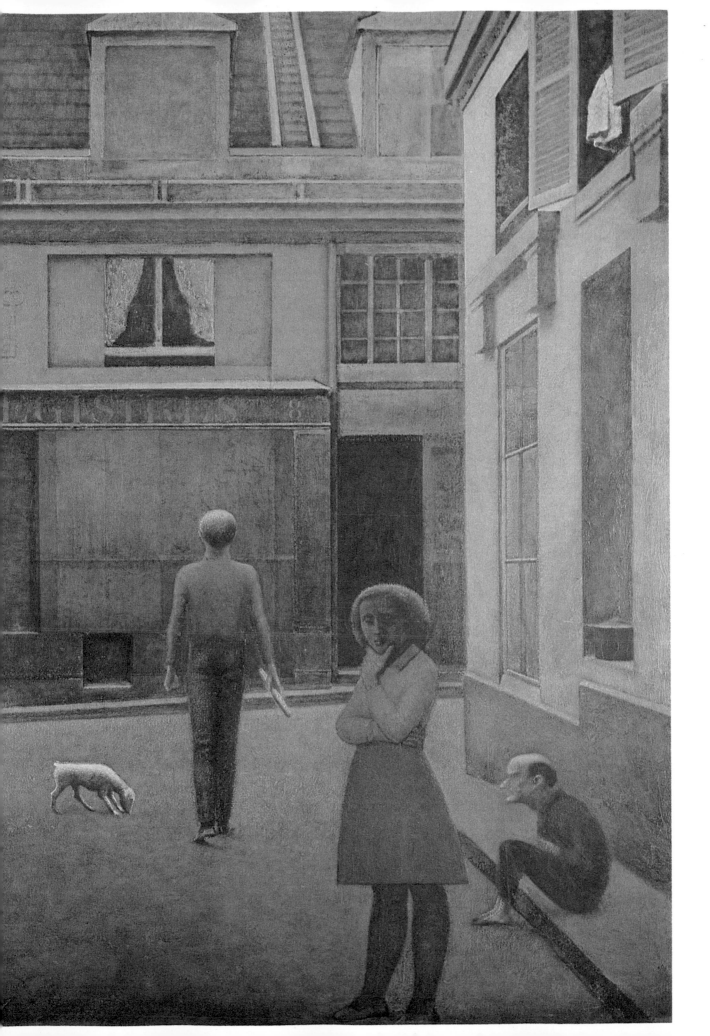

59

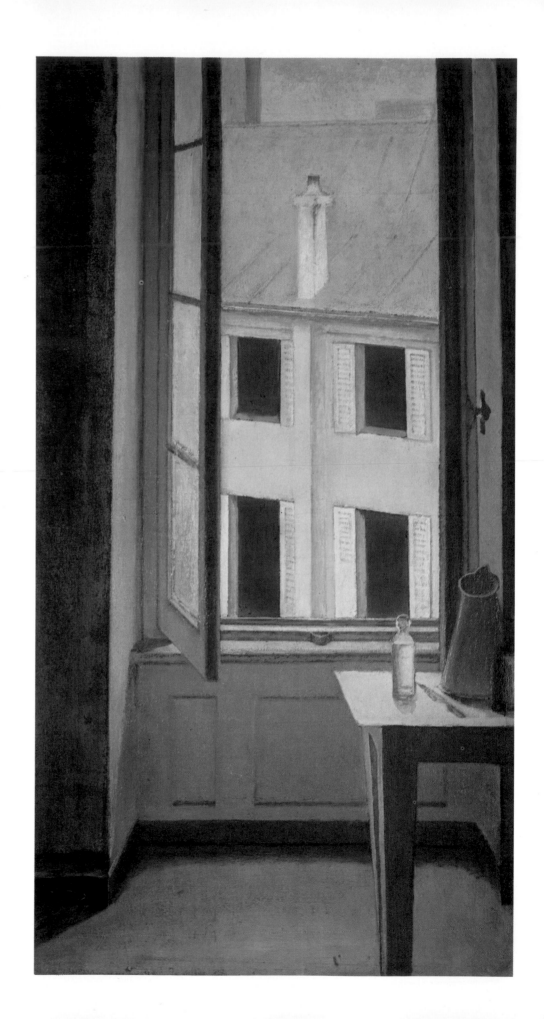

The Window, Cour de Rohan.
1949-1952. (32 $\frac{1}{4}$ × 19 $\frac{3}{4}$ in.)
Collection Pierre Lévy,
Donation to the
French National Museums.

60

The shades of David and Marat haunt this neighbourhood, and the masterpiece of hypnotic Caravaggism which strongly influenced him is David's *Death of Marat*. The arrow under the yellow key painted on the facing wall as a shopsign or an occult signal points towards the locksmith's shop up the way which, inside, houses the base of a tower surviving from the town wall erected by Philippe-Auguste in 1210; and next to the locksmith's is one of the two passageways giving access to the Cour de Rohan. Counting the fleecy, lamb-like dog sniffing the roadway, there are nine figures here as in the second version of *The Street,* but scale, spacing and expression are very different. No longer sleepwalkers issuing from memory and moving with the impetus of a Commedia dell'Arte troupe, these are real people, real-life Parisians on their native ground, and three of them are turning our way and gazing at us pointedly. The bald tramp sitting on the pavement, his shrunken figure bent forward, under a red pot on the sill and some laundry hanging above, is looking intently at the delightful figure group across the way, a fair-haired girl and two children, with beside them an astonishing open-air still life in the shape of a doll and a child's chair. Stalking down the street at the back with her cane and shopping bag is the hunched, ambivalent figure, ever recurring in Balthus, of the old hag and patron beldame; she is also, as John Russell points out in his acute and engaging preface to the 1968 Balthus exhibition in London, the image of old age in this figuration of the "Three Ages of Man"; and her iconographic source would seem to go back to Hogarth and his scenes of urban pantomime. The man seen from behind walking away, out of the circle of enchantment which he has created and in which he remains an outsider, is the painter-magician, Balthus himself: he is on his way back to his studio, which is situated behind the printing office and could be reached by the ladder on the roof, and in his hand he holds a *baguette* of freshly baked bread, in itself almost an emblem of Paris life.

For with him the essential thing, which words cannot convey and which only the connoisseur can enjoy to the full, is the texture of the paints and

the quality of the execution: the geometric layout, the rhythm of the figures, the melody of the light, the reduction of the colour scheme to the three primary colours, modulated by superimposed coats and the use of transparent scumblings. From Derain, Balthus learned the decisive lesson that on a large surface the important thing is not to vary tones but to rely on delicate shades of difference. A transition, he also discovered for himself, may be effected by a break or an overleaping. Paris has been evoked by many artists, and since Baudelaire and the Impressionists it has given rise to a whole new poetics. This picture of *The Passage du Commerce Saint-André* (1952–1954), contemporary with Beckett's early plays and Giacometti's sculptures, sums up a whole period of Balthus' life and bids farewell to the Paris of neighbourhood craftsmen, the Paris of house-painters capable of setting an example for artist-painters. This picture accordingly takes on a solemn grandeur and sounds the knell of those disappearing values whose full resonance it recaptures and enshrines. The note it strikes is not a note of sadness or distress, but of nostalgic celebration, of proud confidence in the stele which painting erects to itself.

From 1954 to 1961, at the turning point of his maturity, Balthus withdrew to the Château de Chassy, in the Morvan (department of Nièvre). While staying at Vézelay with his friends Georges and Diane Bataille and driving with them through this plateau region of pasturage and forests, he had discovered the countryside around Lormes, where Corot a hundred years before had painted some of his finest landscapes. Hearing of a manor-house to let in this region, he rented it, then purchased it. Dating back to the early fourteenth century, the Château de Chassy had been rebuilt in the mid-seventeenth century by the Comtes de Choiseul, the owners of this large estate. It is one of the sentinels of the Nivernais, standing between the upper Morvan and the Bazois, and combining, in flawless proportions and unadorned purity, the two forms of architecture to which he has always been most responsive, feudal sturdiness and classical order. The farmstead and its

Colette in Profile.
1954. (36 ½ × 29 in.)

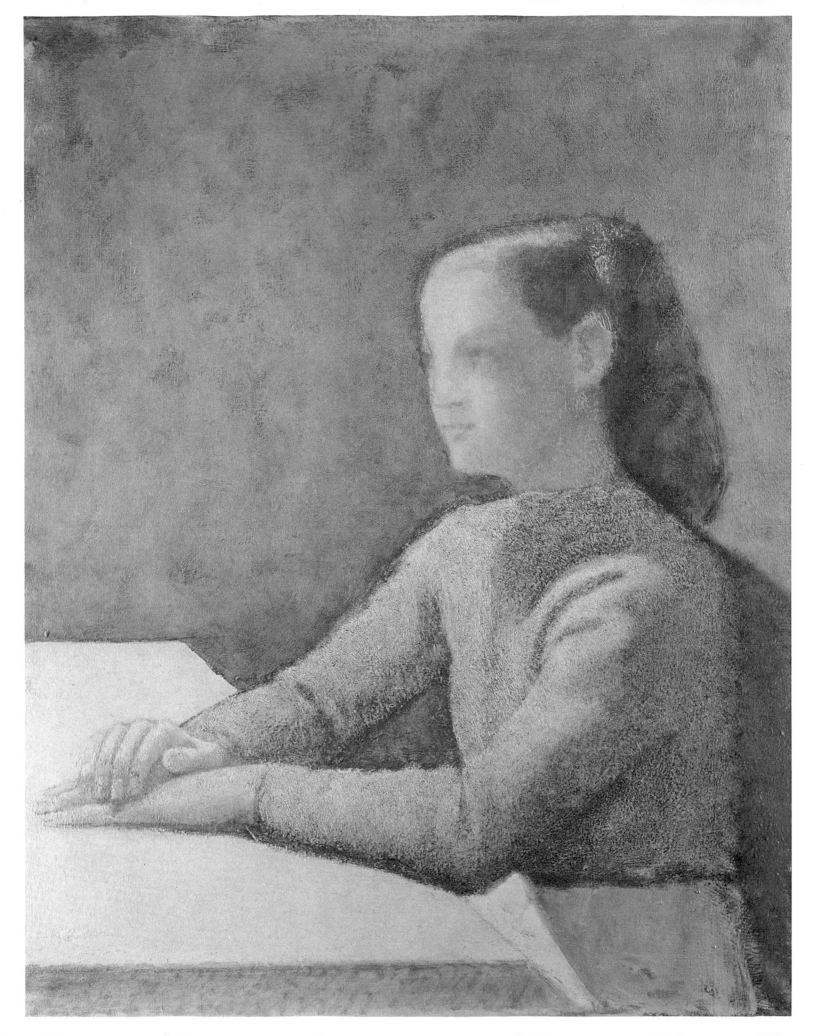

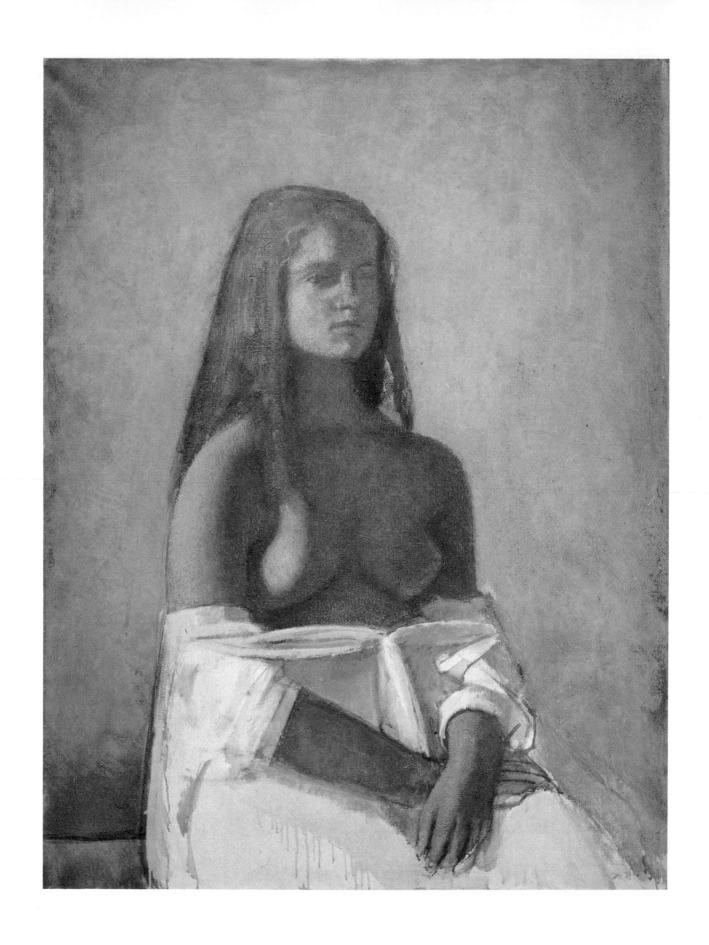

Girl in White.
1955. (46 × 35 in.)

outbuildings, the gates and the inner courtyards, together with the manor-house itself, its corner turrets, burnished roofs and plastered walls mellowed by time, go to form a volumetric and chromatic ensemble of the noblest, most arresting harmony. Overlooking the valley of the Yonne and set among trees of the most varied species, it commands some beautiful views over the surrounding country and its ring of mountains. Mountains whose sagging curves seem, in the distance, to float gently over their granite base. They delimit a typically Celtic enclave in the old duchy of Burgundy, a district whose specific character has been preserved by its very isolation, one that has maintained intact the ancient way of life and peasant customs so well described by Gaston Roupnel in his *Histoire de la campagne française* (1932). For the artist, there is a *spirit of place* as fateful for him as the meeting of two people for their common destiny. In the wandering life of the modern artist and the exile's fate to which he is often doomed, Chassy represents for Balthus not a *place of passage* but a *home*, a place in tune with his deeper nature where, through its archaic ways and seasonal rites, he was able to join up again with the earthbound life of his Polish ancestors and attune himself to rural rhythms not very different from those of the age-old civilization of China where culture really means culture, i.e. the art of tilling the land and gardening, and where the ideogram for "painting" represents a hand outlining a field.

During his Chassy period, when his work was pretty much disregarded by the art critics and his only support came from a few discerning collectors like Henriette Gomès, he worked with unflagging energy, as intent as ever on a slowly achieved, highly wrought perfection. In these half a dozen years he produced some sixty paintings, eighteen of which are reproduced here: they represent every type of picture (portraits, landscapes, nudes, still lifes, figure compositions) and together form one of the most complete and truthful records that an artist has ever given of his surroundings. One of the initial canvases, a work of expectation and metamorphosis indicative of the entire cycle, is *Colette in Profile,*

the daughter of the neighbouring mason called in for the work of restoration. Wearing a blouse of periwinkle blue and sitting at a straw-coloured table where her hands are crossed over their secret, she is eavesdropping on the pulses of her being, on the mystery that transforms her body. Her face, radiant with light streaming from some outside source or emanating from within, with both eyes so neatly and unexpectedly visible despite the side-face view, emerges from the brownish dappled background, as if brightly suspended on the waves of time. The *Girl in White*, about a year later, marks the first appearance of Frédérique, at sixteen, who henceforth reigns over these premises, occupying the various rooms of the house with her various poses, as she reads, plays cards, daydreams, looks out of the window, or grooms herself. She appears in the freshness of her girlhood and in the pride of her early maturity—majestic stone and vibrant flesh, icon of Egypt and draped nude of Ionia. The alabaster shift with bluish glints, slipping nearly to her waist, bares her shoulders and breasts and closes up its shadowy folds between the shapely arms and crossed hands.

According to the season and aspect, the many windows of the three-storied house at Chassy command a variety of landscapes, every one of them setting the painter its challenge of expression and accuracy. In his hands their harmonic pattern, under the simplicity of appearances, is quite as strict as that of his townscapes and interiors with figures. Here the painter's own creative rhythm is in unison with the organic rhythm of nature and its age-old respiration. Some kind of osmosis occurs between the real substance of the earth and the earth pigments which he uses to render its texture and density. This remote countryside of the Morvan, recaptured in its serene spiritual dignity, suggests of itself the movement which transposes it into painting and which thereby reveals from the depth of ages its sacred essence.

The *Big Landscape with Trees* and the *Bouquet of Roses on a Window Sill* show from different angles, in the glow of spring and of summer, the

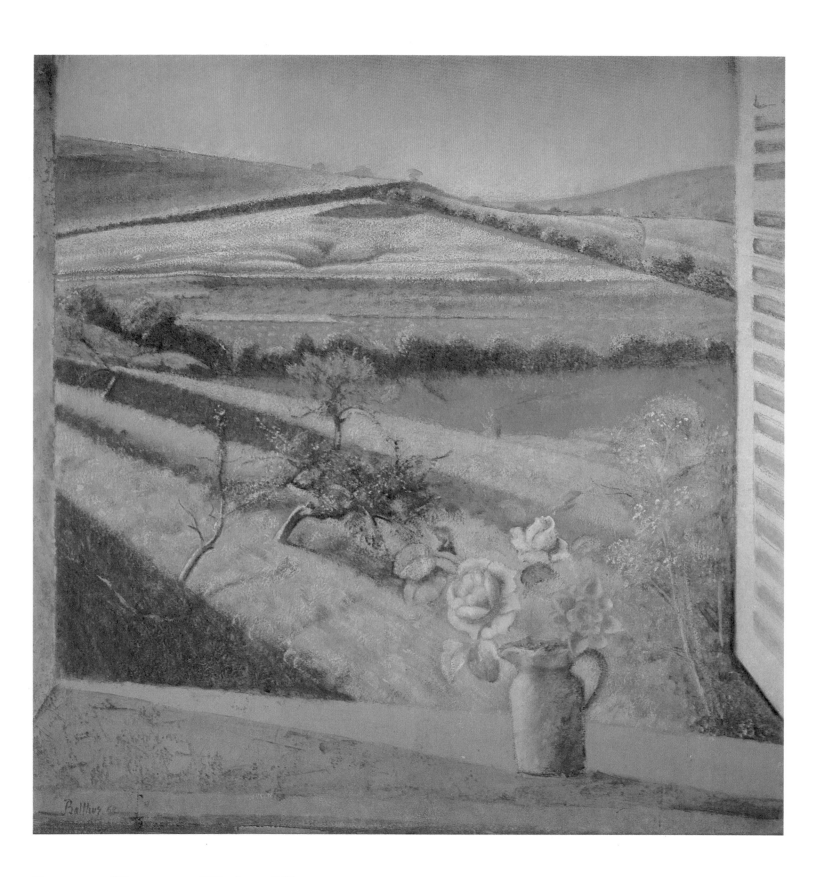

Bouquet of Roses on a Window Sill.
1958. (52 ³/₄ × 51 ¹/₂ in.)
Indianapolis Museum of Art, Gift of Joseph Cantor.

Big Landscape with Trees
(The Triangular Field).
1955. (45 × 63 ³/₄ in.)

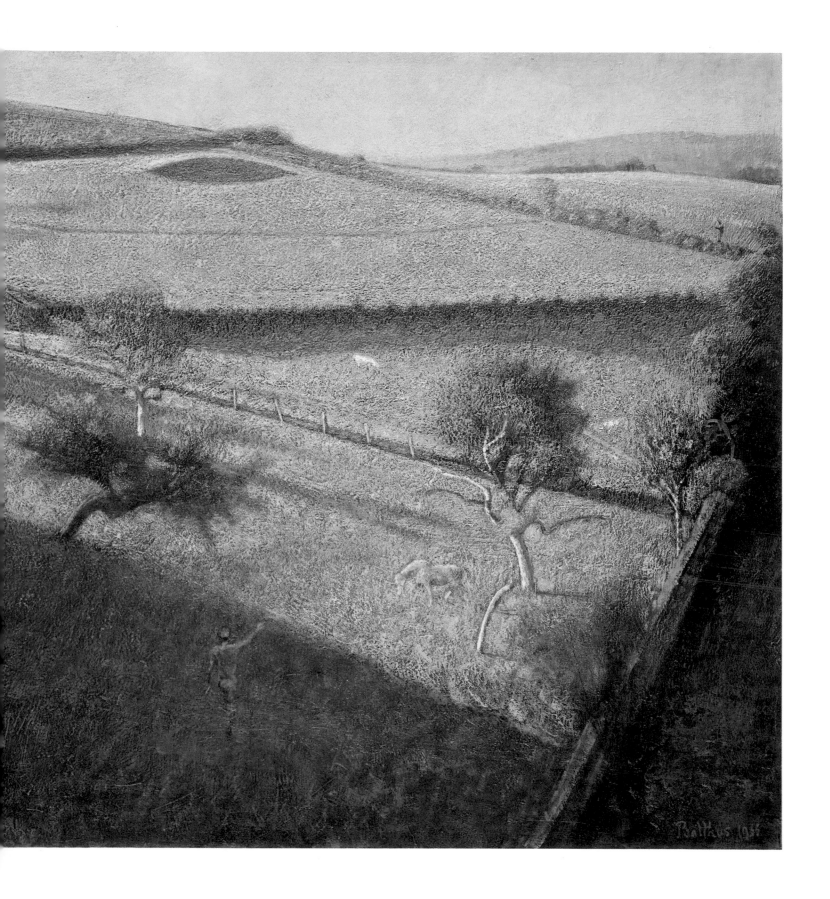

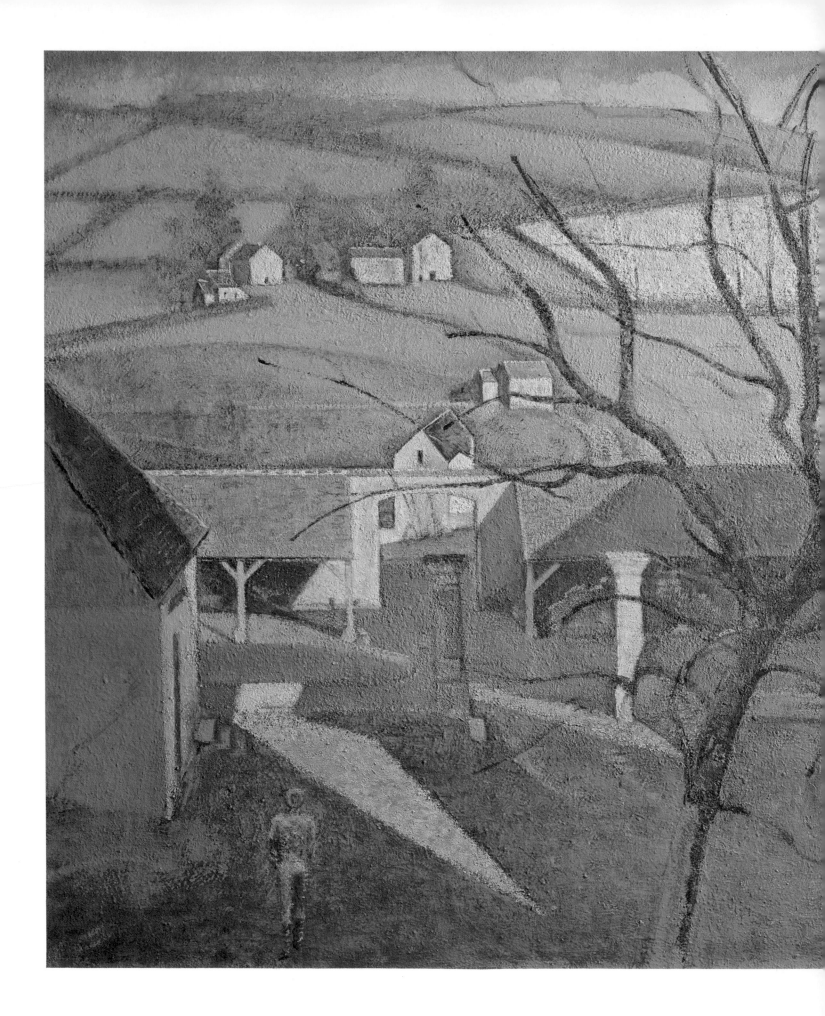

Big Landscape with Tree.
1960. (51 $\frac{1}{4}$ × 63 $\frac{3}{4}$ in.)

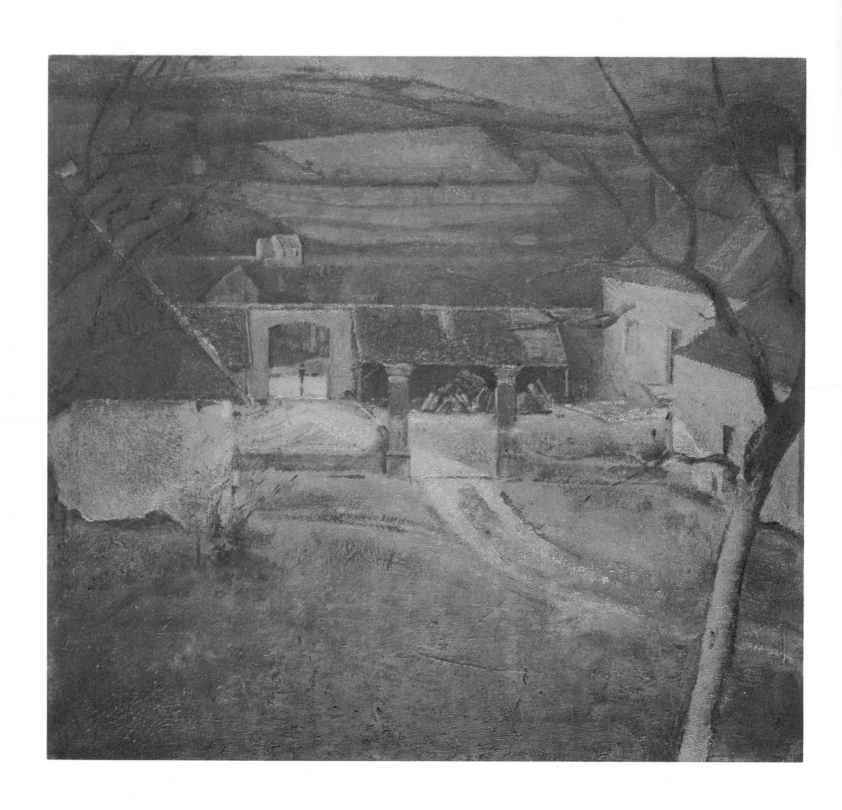

Farmyard at Chassy.
1960. (35 × 37 ³/₄ in.)

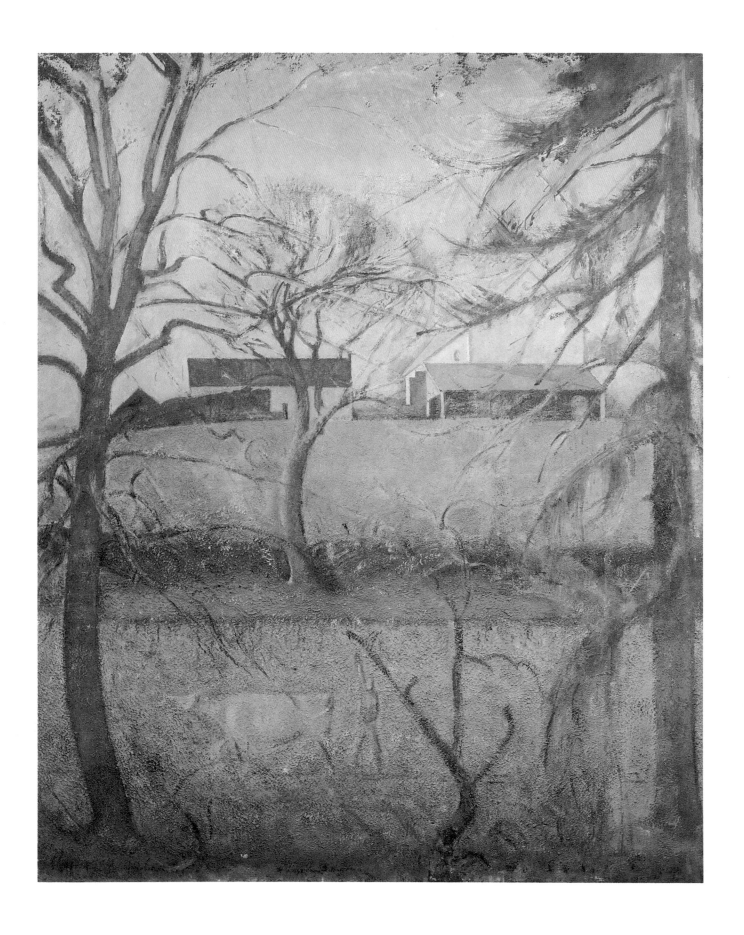

Big Landscape with Cow.
1958-1960. (64 × 51 ¹/₄ in.)

same gritty stretch of ground that slopes away from the north tower. Transversal strips follow one another, thick meadows and apple orchards with low gnarled trunks, jutting out horizontally and overhanging the serried clods of the rhomboid field in which a darker oval shape looms up like an eye. The horizon rises sharply to the narrow luminous sky. The hedge-rows peculiar to this part of France mark off the plots of ground with their alternating shadows and lights, each plot a self-contained part in the rich compactness of the whole. The man with Orphic gestures and the Virgilian animals inscribe their punctuation between the arabesques of the trees, whose calligrapher is the wind. Such is the *Big Landscape with Trees*. In the *Bouquet of Roses on a Window Sill,* the full-blown flowers in a jug suggest a human presence, they suggest a feminine touch; and they interiorize the landscape beyond, with its blossoming trees, and regulate its spacing out. The French poet Francis

La Bergerie.
1960. (19 ³/₄ × 39 ³/₈ in.)

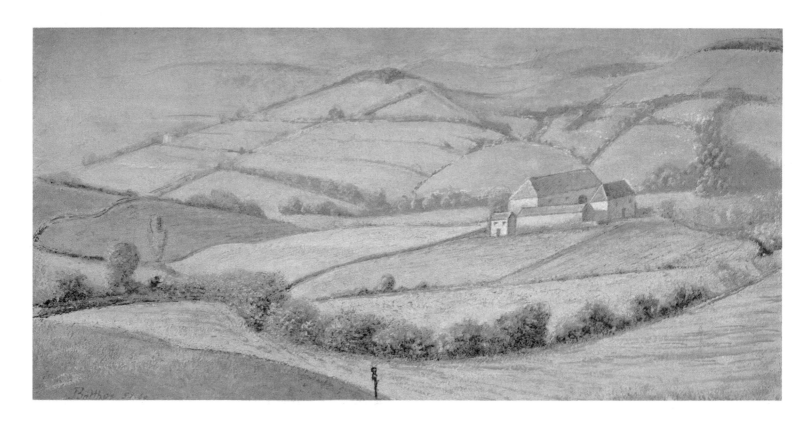

Ponge, a man so close to the substance of things, to the rhythm of plant life, was so moved by these landscapes of Balthus that, using words like pigments, he attempted in one of his poems to render the exact tenor of a meadow, the saturation of its colour:

> *Prendre un tube de vert, l'étaler sur la page,*
> *Ce n'est pas faire un pré.*
> *Ils naissent autrement.*
> *Ils sourdent de la page*
> *Et encore faut-il que ce soit page brune.*

The *Big Landscape with Tree* and *Farmyard at Chassy* are oblique and plunging views in winter lighting of a twofold motif: in the foreground, the entrance gate and the farm buildings set out round the courtyard and the leafless tree; in the background, beyond the mill and the valley of the river Yonne at the start of its course (the subject of several separate paintings), the upward slope of the hill with its terraced fields and the robust blocks of houses roofed with tile or slate. In the smaller version, pitched in a cool tonality, the greens, blues and mauves have the beaming radiance of grasslands and precious stones; in the monumental version, where the dominant tones are ochre and beige, the February sun casts strange patterns of light over the velvety ground. The *Big Landscape with Cow* represents, at Easter time, the view from the back of the house over the former moat on to the neighbouring farm and its fold of ground. The rust-coloured fields, the pink farmhouses and the clear blue sky, more extensive than usual, mark a graduated sequence of levels and tilt forward the successive picture planes. To either side rise the bare jagged branches of ash and larch, ramifying in a kind of trellis-work. The rock-like figure of the cow and the majestic cowman with upraised arm break through the clayey soil and give this august landscape its mythical accent. The picture is pure Balthus, and all the more characteristic for its resonant echoes of Chinese landscape and the "Seasons" of Poussin. *La Bergerie* ("The Sheepfold"), the only view unconnected with the manor-house, is one of the extensive outlying farmsteads that once belonged to

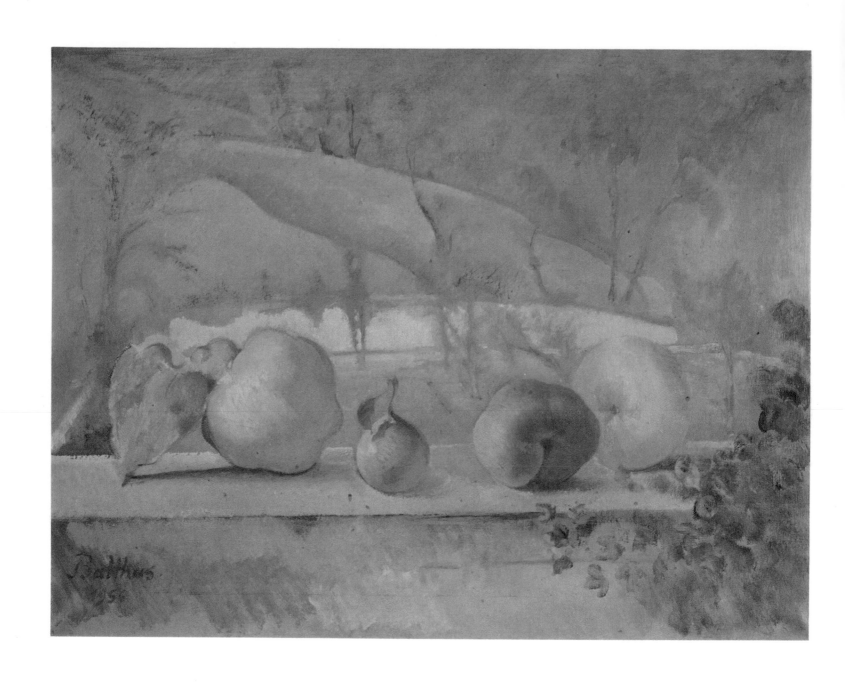

Fruit on a Window Sill.
1956. (26 ¹/₄ × 34 in.)

the vast estate of Chassy. The house, barn and adjoining stables form a volumetric mass on which the colours are concentrated: around that mass extends the pattern of fields bordered by copses and shrubs, their sheets of green shadow and blonde light unfolding over the rising and dipping ground. Distinguishable in front is a tiny human silhouette, tensed like a Giacometti figure. This small panel painting, vibrant with the pulse of earth, is a connoisseur's masterpiece of the same type and quality as the *Italian Landscape* of ten years before. The landscape is a complete organism including within the sweep of its elements man, his works and his dreams, not transient individuals but mankind as a whole and the abiding trace of generations. It offers Balthus free scope for his purest accomplishments, a natural pretext for the patiently achieved order and colour harmonies which he has always aimed at, the Elysian accord of ochre and lilac, the tones of ripe olive, fiery rust and threadbare velvet which are those of the earth before and after snow.

The canvas of *Fruit on a Window Sill* is a happy marriage of landscape and still life. It was based on two preparatory watercolours, one of the quinces, the other of the apples, and it retains the transparency and fluidity of watercolours, in contrast with the thick and grainy texture of the previous oils. By way of Courbet and his veristic intensity, it recaptures the freshness and élan of certain old-master paintings. A metaphor and model of painting, the window is the ductile link between the inner world and the outside world. The Baroque theme of still life in a window had been taken up in their own particular ways by Cézanne and the Cubists. The intimist theme of a figure at the window, invented by the Dutch masters and exploited in an anecdotal vein by the Romantics, has also been taken up and freshly handled in modern painting and poetry. "To my mind," writes Gaëtan Picon in a fine essay in which he makes us feel the baffling sense of disquiet analogous to paramnesia that emanates from this painting, "it is in the pictures of an adolescent girl at a window opening on the barely suggested profusion of a garden, seen dreaming, dozing or gazing, that Balthus approaches

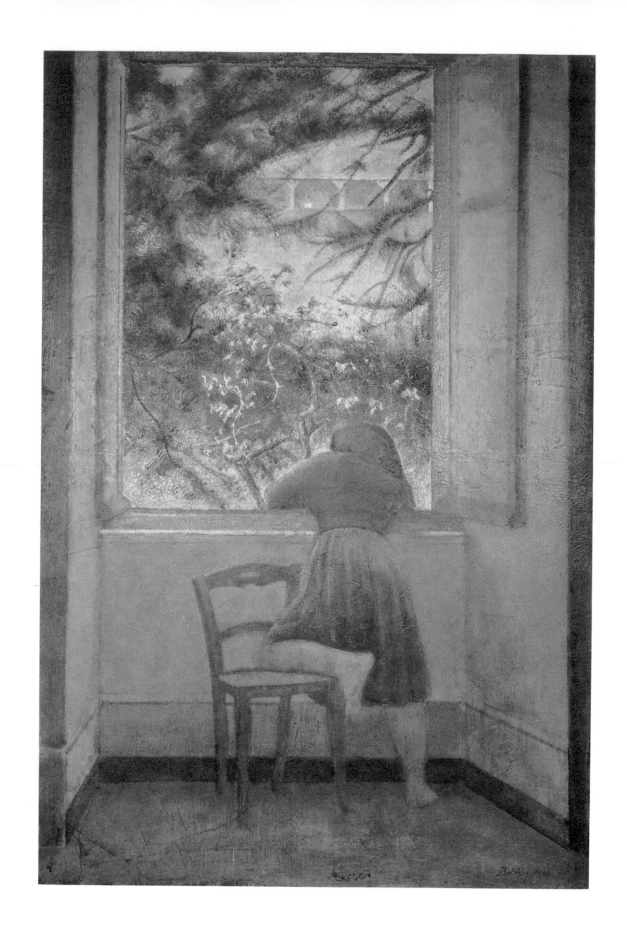

Girl at the Window.
1955. (77 ¹/₄ × 51 ¹/₄ in.)

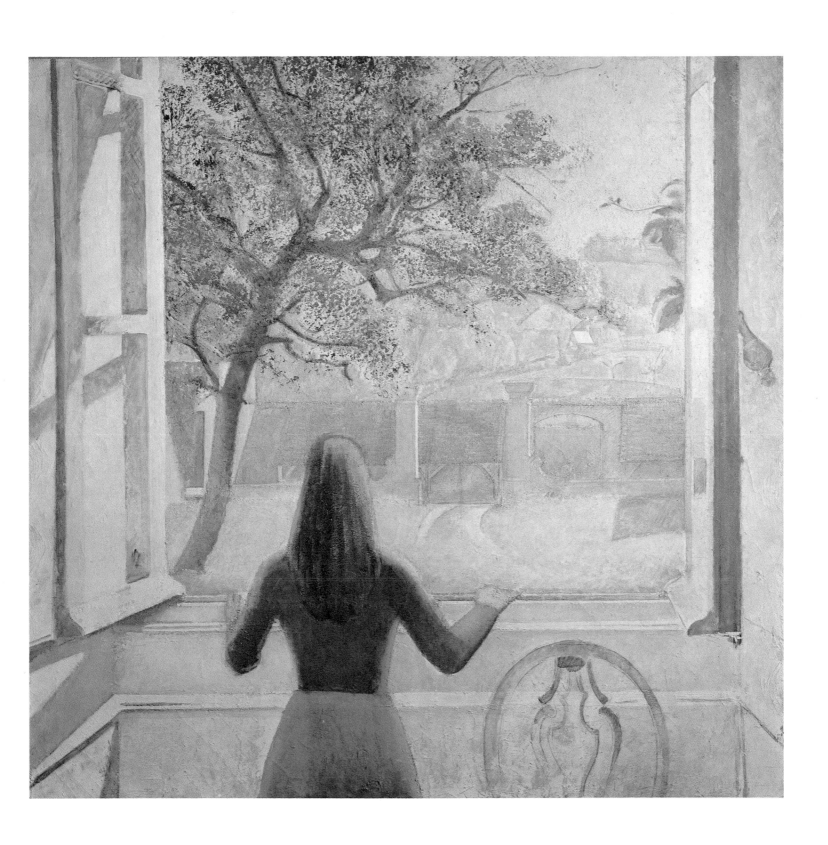

Girl at the Window.
1957. (63 × 63 ³/₄ in.)

79

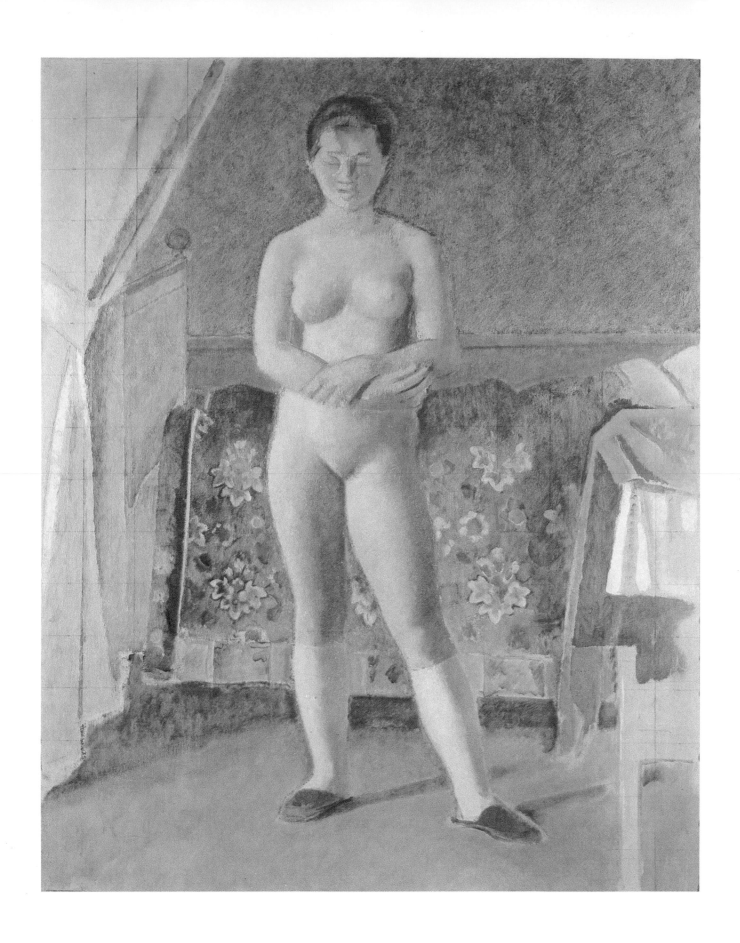

The Toilette.
80 *1957. (63 × 51 ¹/₄ in.)*

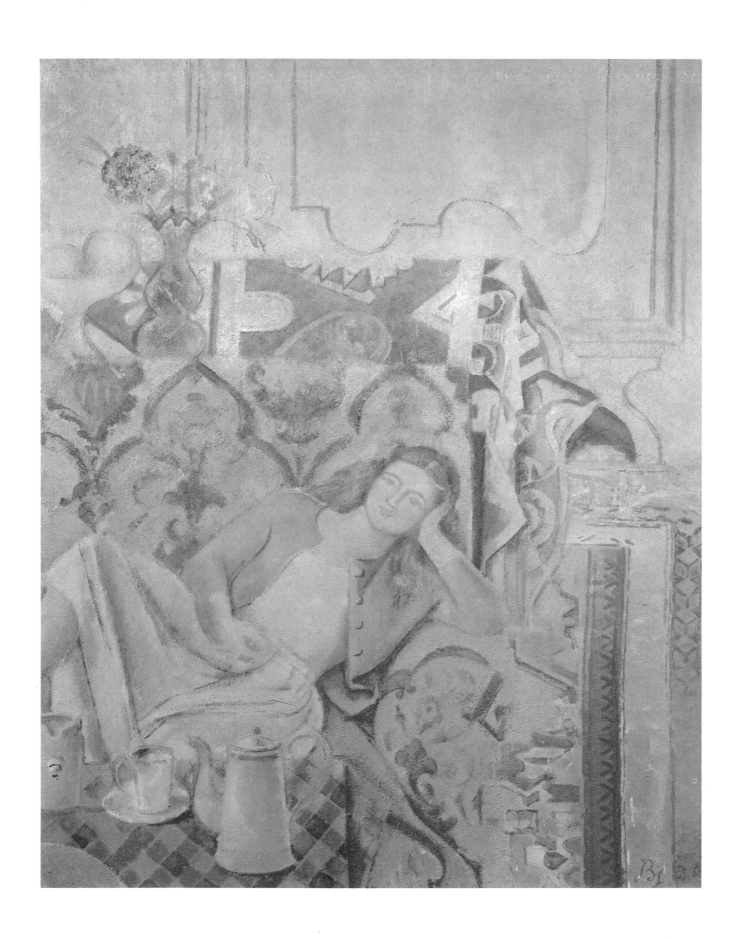

The Cup of Coffee.
1959-1960. (64 × 51 ¹/₄ in.)

most nearly to his true home. Here are two versions, from two different storeys and two different sides of the Château de Chassy, of the *Girl at the Window*. In the first, where the room space predominates over the slighter frame of greenery, she is seen in full-length, standing in the embrasure against the light, with one leg doubled up on a chair; blocked out in red and blue, like one of Masaccio's massive figures, she cocks her dark head over the sill at a three-quarter angle to catch sight of something down below. In the second, where the outdoor scene prevails over the room space, she is standing in half-length, seen directly from behind, her hair falling loose over her shoulders, her hands resting on the sill of this larger casement which sets off the rounded back and scrollwork of a Venetian chair. Her unseen face is nevertheless present with hallucinating intensity and through her eyes we gaze at the bright familiar world beyond, the distant hill, the courtyard and sheds, the arching leafage of the maple-tree. Rilke, in his last home in the Valais, wrote directly in French a set of poems on windows, dedicated to Baladine, Balthus' mother. Some lines from one of them might almost apply to this picture:

> *Elle passe des heures émues*
> *appuyée à sa fenêtre,*
> *tout au bord de son être,*
> *distraite et tendue.*
>
> *Comme les lévriers en*
> *se couchant leurs pattes disposent,*
> *son instinct de rêve surprend*
> *et règle ces belles choses*
> *que sont ses mains bien placées.*

The Chassy pictures based on the human figure and domestic life baffle definition and comment, such is their evident perfection and secret symbolism. *The Toilette,* in which the squaring of the canvas remains visible, is one of the very few paintings which Balthus has executed

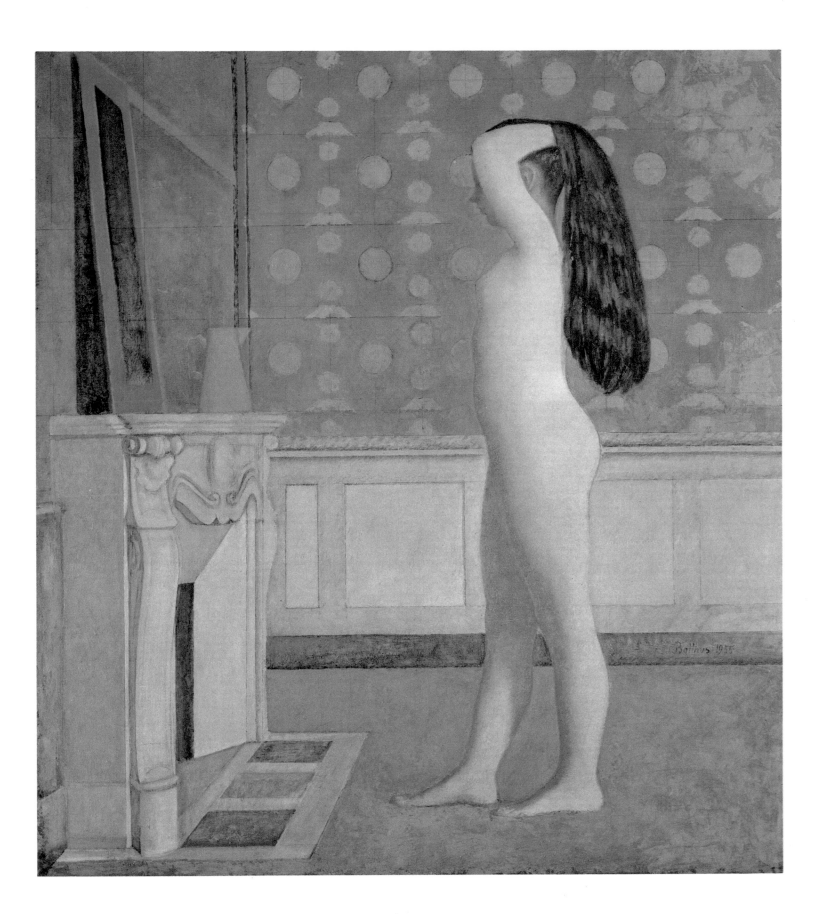

Nude in Front of a Mantel.
*1955. (77 × 64 1/2 in.) The Metropolitan Museum of Art, New York,
Robert Lehman Collection, 1975.*

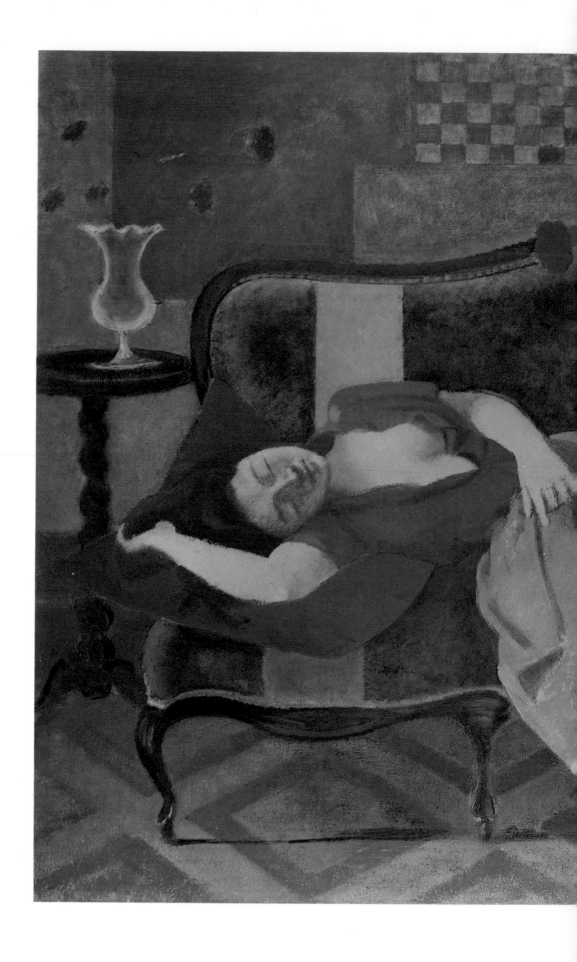

84

The Dream I.
1955-1956. (51 1/4 × 63 3/4 in.)

Boy with Pigeons.

86 *1959-1960. (63 ³/₄ × 51 ¹/₂ in.)*

The Fortune Teller.
1956. (78 3/4 × 78 3/4 in.)

rapidly, with light scumbling over the background, for the sheer pleasure of unfurling round the white-stockinged, red-slippered nude, without impairing her posture and texture, the exuberant patterns of the Provençal coverlet. In *The Cup of Coffee* the treatment is much more elaborate. The dreamy figure leaning back along a diagonal fits smoothly into the profusion of the setting, furniture, fabrics, rugs, coffee set, bowl of fruit, vase of flowers, all merging into a continuous harmony of refined and mellow colours whose effect is to abolish depth.

With the *Nude in Front of a Mantel,* whose attitude was taken from a magazine photograph, the reverse effect is obtained and the bright ring of space circles round the statuesque figure with its heavy head of hair, in the architectonic calm of ordered numbers and the soft play of surrounding light. The version of *The Dream* reproduced here is the first of a series of three on this theme. The sleeping girl in a green blouse and pink skirt lies in charming disorder on the blue sofa, her loose hair strewn over the mauve cushion under her head. Her soul has left the house of her body and flutters in the room, looking on at her dream. A heavenly messenger, her luminous features in profile, tiptoes towards her with bare feet, holding out a red poppy, to which answer the entranced flowers in an opaline vase on the mahogany pedestal table. In one of Coleridge's poems a girl dreams that she is walking through paradise and an angel gives her a flower as a token of her visit. The poppy of slumber is also one of the attributes of Demeter, the goddess of corn, harvest and fruitfulness who presided over the Eleusinian Mysteries.

The *Boy with Pigeons,* who stands gaping in his templar's jacket, has paused while prosaically watering some splendid green plants worthy of Braque, on the chequered tablecloth, to look up at the sudden wings of poetry beating at the windowpanes in a golden, honey-coloured radiance. "How did writing come to me?" asks René Char. "Like bird's down on my windowpane in winter." *The Fortune Teller* reigns over a large square canvas whose setting is the drawing room at Chassy. The

The Moth.
1959-1960. (63 $\frac{3}{4}$ × 51 $\frac{1}{4}$ in.)

harmony between space and light, between the curves of the chairs and the straight lines of the fireplace, between the bright colours of the figure and their muffled reflections on the threadbare carpet, is reminiscent of Vermeer. The self-possessed girl with her tarot cards aligned on the round pedestal-table like constellations on the march awaits the decision of fate with the gesture and glance of Solomon pronouncing judgment in the famous picture which Poussin considered his best work. There are diurnal interiors of crystalline limpidity and nocturnal interiors of phosphorescent constriction. *The Moth* is one of those disquieting, premonitory pictures whose apparent meaning overlays a hidden meaning which intensifies its magic. A female nude of priestlike demeanour, holding her emblematic towel over her arm, is trying to catch the dazzled moth fluttering about the lamp and soon to be consumed by it. A taller, slenderer figure than most of Balthus' nudes, the girl is seen in profile like an Egyptian bas-relief in the narrow space between the clay of the wall, the heaped-up bedclothes, and the bedside table with carafe and oil lamp, whose soft glow is as beautifully rendered as that of the wood fire in *The Golden Days*. The butterfly, in Greek mythology and Persian literature, symbolizes the soul destined to be consumed by the flame of love. One of Pierre-Jean Jouve's spellbinding novels, dramatically combining the mystical quest and sensual ardour, opens with the description of a room and the heroine's confrontation with the symptomatic death of the moth. This picture, a turning point in his work, is steeped in a rich, earthy texture bound up with the soil of Chassy, with the fruitful, seed-bearing earth from which the glorious flesh and all the elements have proceeded.

In 1961 André Malraux, as Minister of Cultural Affairs, asked Balthus to take over the directorship of the French School in Rome—the Académie de France. This was an official post which might have seemed ill-suited to a temperament like his but which, owing to exceptional circumstances, he accepted and occupied for the next fifteen years, with singular prestige and results that amount to a positive achievement, for

though at first they encroached on his activity as a painter they served his country and its relations with Italy. For a century and a half the Académie de France has been housed in the Villa Medici on the Pincio. With supreme tact and an instinctive sense of fitness, he was able to restore its pristine harmony to one of the most enchanting houses in the world, to remove the coats of whitewash concealing its old frescoes, to carry out the reforms necessary to give new life to the institution, to create the galleries and organize the exhibitions that are by general consent among the finest in Europe. This restoration took much of his time, but in itself it constitutes one of his most perfect works and it has had a beneficent effect on Balthus himself and on his painting. After taking up his duties he carried out several missions to Japan with a view to exploring its art treasures and the vitality of its folk traditions. From Japan he brought back his young and charming companion, Setsuko, a patrician beauty bred in accordance with the ancient rites of Chinese inspiration, and through her he gained an insight into the secret life of the country and communed from within with that legendary civilization of the Far East which has haunted him since childhood and which Claudel has called *"la patrie primitive"*. He learned colloquial Japanese and the rudiments of writing, perused all the books on the subject and read through Japanese literature in the various translations available. The best compilations of Ukiyo-e and Osvald Sirén's classic volumes on Chinese painting were always with him. This Roman period of his has only just ended, and it is too soon to appreciate its effect on him, privately, socially and artistically, coming as it did in the aftermath of his Chassy period. The conquests of painting have transcended the vicissitudes and vexations of life, and in this aesthetic survey there is no call to dwell on the latter. Apparent display against an austere background: such is the discipline of style.

The Turkish Room actually exists at the Villa Medici. Designed by Horace Vernet when he was director (1829–1835), it reflects the Orientalist fashion of that period, a fashion which also owed much to

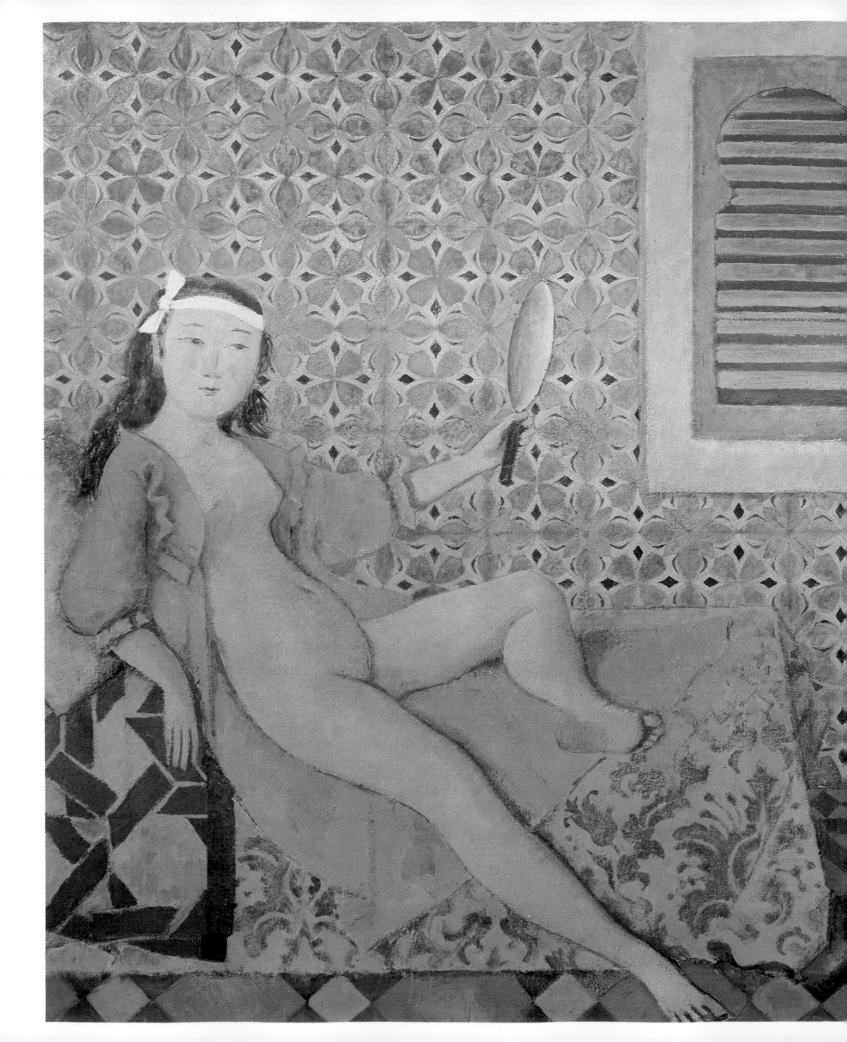

The Turkish Room.
1963-1966. (71 × 82 ³/₄ in.)
Musée National d'Art Moderne,
Centre Georges Pompidou, Paris.

the young Ingres, Balthus' most eminent predecessor as director of the French School in Rome (in 1835–1842) and an artist whom Balthus admires, with whom he is at odds, and who puts him on his mettle. His *Turkish Room* was the first of his works to enter the French National Museums. It accurately depicts the room with star-patterned tiles in which reclines the mauve, spindle-shaped Japanese nude in a pink morning wrapper against the blue and saffron-coloured wall–a figure victorious over mere *japonisme* or *japonaiserie*. Balthus has succeeded in surmounting on its own ground the Orientalism which persisted in modern Western art down to Matisse, and in the really universal vision which he can now command he has attained that fine Oriental transparency which excludes exoticism. "With *The Turkish Room*," writes Patrick Waldberg, "Balthus renounces the simulated depth of perspective and chiaroscuro which singularizes the work and at the same time isolates it. He renounces it in order to arrive at true depth which is essentially a matter of transparency." Colour does not exist in itself, as naïvely assumed by contemporary aesthetics, and the role of painting is, as here, to transmute it into light. Between the slatted shutters and the beribboned face of the strange odalisque is interposed the moonlike looking-glass. The time-honoured vehicle of Western narcissism, the mirror in Japan is a medium of lustration or the empty form of the *tao*, which grasps at nothing and repels nothing. At the right are some still-life items: on the grey table a dish of unidentifiable fruit, on the green table a cup and a stoneware jar, a discreet homage as it were to Morandi.

The Japanese woman dispenses with chairs and inside the house lives close to the floor, on cushions and matting; hence the litheness of her body and her creeping movements. The pair of companion pictures executed over nearly a decade, *Japanese Girl with Black Mirror* and *Japanese Girl with Red Table,* are apt to be puzzling to western eyes accustomed to a different conception of the nude, as fixed by Greek statuary and Venetian painting. Exhibited in New York at the Pierre Matisse Gallery in 1977, where they created a sensation among a

94

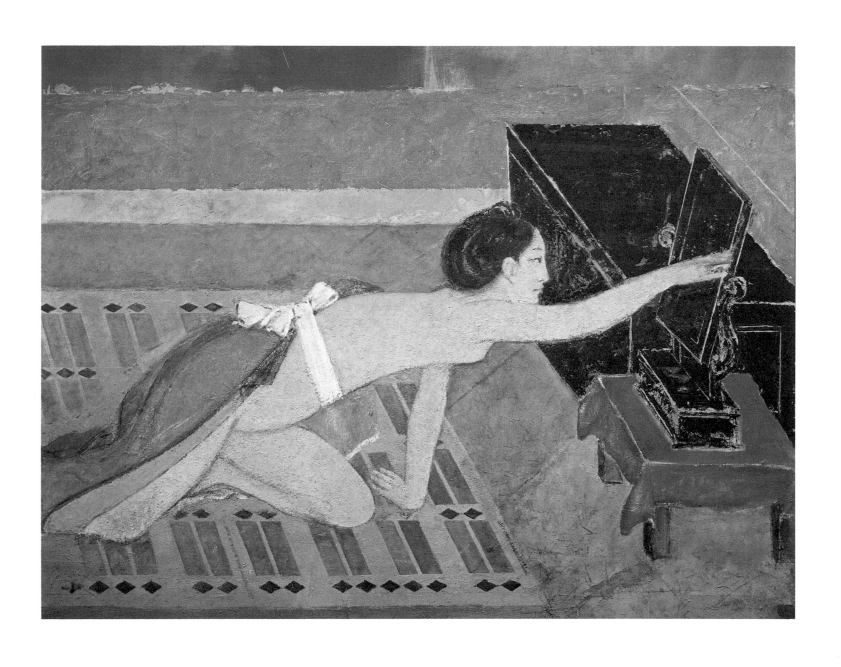

Japanese Girl with Black Mirror.
1967-1976. (59 × 77 in.)

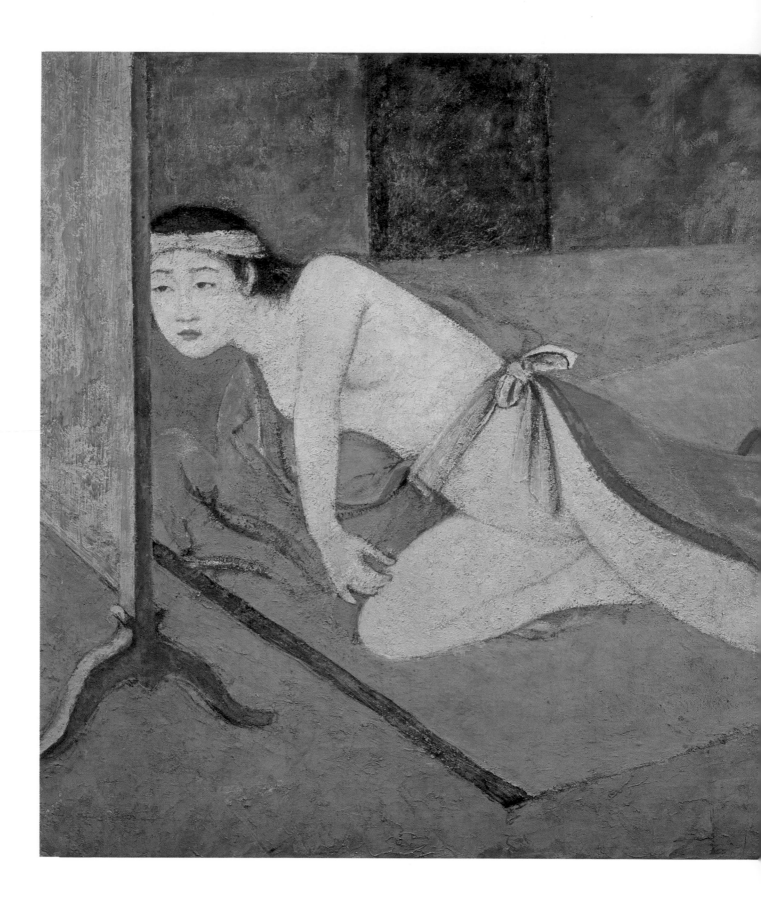

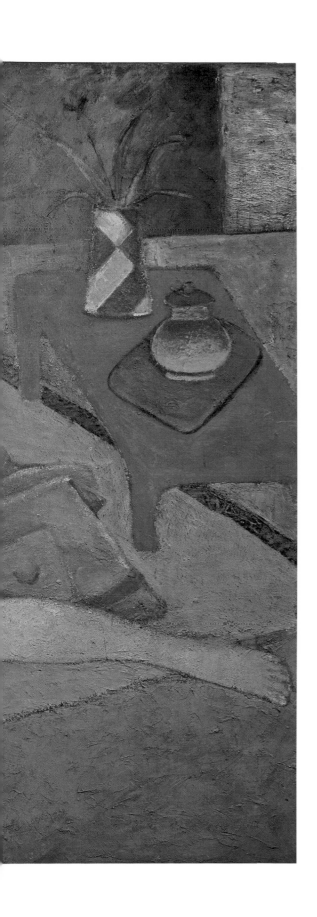

Japanese Girl with Red Table.
1967-1976. (57 × 75 $\frac{1}{2}$ in.)

The Oil Lamp.
98 *1960. (20 × 16 in.)*

cosmopolitan public of art lovers, they were hung side by side on two walls at right angles to each other, thus emphasizing the polarity of the two works, as revealed here too by their reproduction on facing pages. By seeing them as pendants, one actualizes the duplication suggested in each picture by the presence of a mirror: a table-glass towards which strains the face in profile with hair done up in a chignon, and a cheval-glass gazed at with magnetic eyes by the face in front view crowned with a bandeau. But in both cases the mirror ardently consulted by the young proselyte is the purificatory mirror of Hindu maieutics, in which by introspection one is supposed to see not the bodily reflection but the divine essence that each bears within himself. Woman is inseparable from her finery, and jewelry and fabrics have numbered among the fabulous art of all countries. But while the painting of Balthus, which depends on a matt finish and not on scintillation, rules out jewelry (also for intrinsic reasons), it reserves an essential place for fabrics and domestic objects; it gives them a self-contained and not a merely decorative existence. On the geometric field or the uniform surface of the mat, the supple rhythm of the kimono accompanies the flexions and elongations of the spellbound body, each sensitive point of which is brought out by that natural spiritualization of the nude peculiar to the East. The *himo*, the ashen-white or fire-pink ribbon knotted round her waist, is like a cilice of sensual pleasure. Perspective is disrupted in order to comply with the tactile suggestions and the overhead views, and the back wall is decorated with horizontal bands of colour in one case, with vertical bands in the other. The long-meditated colour scheme was finally worked out when he found the garnet-red of the low table and the ebony black of the chest.

His move to the Villa Medici satisfied his aristocratic instincts, and he was led to buy and safeguard a feudal castle in the Etruscan country—equivalent of the Celtic country in France. It marked his return to the Italy he had known so well in his youth, and consecrated his ecumenic marriage with the Far East. With the French students at the

Sleeping Girl.
(26 ³/₈ × 22 in.)

Villa Medici, who were intrigued or stimulated by his presence, his relations were very cordial and sometimes quite close, in the case for example of so serious and gifted a painter as François Rouan, who developed rapidly under his guidance. In Italy, in addition to artists, he associated chiefly with writers and stage and film directors. Valerio Zurlini has given an account of a dinner with Balthus, together with the painters Renato Guttuso and Lorenzo Tornabuoni, followed by a long, enchanted walk through Rome in the October night at the French painter's side, and under his spell, for he proved himself the best connoisseur of them all in appreciating the powerful philtres of that city. While Rome did not enter his art directly, something of its antiquity, something of its humanist tradition, did enter it. At the foot of the Villa Medici gardens, which he redesigned with the help of Michel Bourbon, and which is haunted by so many illustrious shades, he chose for himself the studio huddled against the terrace of the Bosco, full of laurel and acanthus, beside the Loggetta which Velazquez depicted in his *View from the Villa Medici* (Prado, 1650–1651) and which Balthus could never walk past without pausing and musing there for a moment. Federico Fellini, one of the few visitors admitted to his studio, grasped intuitively what some might take for the caprices of an aesthete but what is in fact the sacramental character and inspired rightness of his art: "I had already known Balthus for several years when he asked me, almost by chance, to visit his studio. And even the very day of our appointment he acted as if he would have liked to postpone the moment, to extend the waiting... Was this the representation of a 'vigil'? A lustral rite? I imagined that, as the pilgrims do before reaching the holy place, he had to free himself without haste of the dross and dust, to purify himself, so to speak. And thus the image I had conceived of him was filled in: initiatory, priestly, entrusted with a symbolic patrimony in which time had deposited the sediments of arts."

The poet Piero Bigongiari has described the secret refuge where these pictures are formed by slow concretion like madrepores, and where he

The Card Game.
1968-1973. (74 ³/₄ × 88 ¹/₂ in.)
Boymans-van Beuningen Museum, Rotterdam.

witnessed the gestation and transformations of *The Card Game* now in the Boymans-van Beuningen Museum, Rotterdam: "I saw his card players, after an interval of months, change position and game, in a contest which was that of the painter himself with their actual existence, their very credibility in the decisive existence of their particular contest calculated to the limits of its ultimate improbability–in other words, their chromatic scansion working itself out in psycho-plastic masses within a grey space: Parcae-men who hold the thread of the game of life and seem to weave it and rework it, unable to decide to break it by an act of victory which, all things considered, would be pointless." The card game is a theme that fascinated the Caravaggesque painters intent on lighting effects. Cézanne, in painting his Provençal peasants playing cards, set them up like solemn monuments to his own power of concentration. The fateful theme of cards has been treated several times by Balthus, either as a game of patience and divination in which a solitary woman is absorbed, or as an open contest between two people with their destiny at stake. As regards the attitudes, the Rotterdam painting is a replica in reverse of a composition executed twenty years before, but the expressive tension and pictorial regime, which now partakes as much of fresco as of oils, have been amplified. In the unrelenting game which the two partners seem to have been playing for centuries, with no score as yet recorded in the open notebook (over which, however, the woman has control), the terrifying glance they cast at each other across the table comes straight from a scene of the Kabuki theatre in which two clan chiefs thus defy each other for a brief moment before closing for the death struggle. With the precedents of Japan in mind, we can gain a better insight into the metaphysical theatre of cruelty called for by Antonin Artaud and into the hieratic dramaturgy of Giotto as he captures gesture and glance at their paroxysm.

While staying with friends at Biarritz in August 1954, Balthus was struck by the physical grace and harmony of their daughters, three adolescent girls who filled the summer house with life. Taking them singly or

The Three Sisters.
1960-1965. (51 $\frac{1}{4}$ × 75 $\frac{1}{2}$ in.)

The Three Sisters.
1964-1965. (50 × 67 in.)

The Three Sisters.
1966. (51 $\frac{1}{2}$ × 69 in.)

grouped, he made a series of pencil sketches and oil studies which resulted, ten or twelve years later, in the three monumental versions of *Three Sisters,* painted in Rome. Treated as portraits but also as antique columns (which, as Poussin put it, are only ancient copies of them), the three shapely girls are set out like an Olympian frieze in the room which they occupy, while in both versions of *The Living Room* at Champrovent the two contrasted figures are placed asymmetrically on different levels. This triple rhythm, the one in the many and no longer the conflict of the dual, is the perfect rhythm which universally governs the human order and the divine order, which controls the external space of pediments and the internal space of churches. All three versions are centred on a sofa covered with figured (but in each case differently figured) velvet where the eldest sister, Marie-Pierre, sits enthroned like a sphinx in the same sun-coloured dress whose depth of tone changes in each picture: she is the fixed axis round which the other two sisters gravitate. In each version the respective *positions* of the figures between the furniture and rugs have been calculated and regulated according to the soundest laws of *composition.* The largest or rather the longest version (for the height is about the same in all three) is the one with the richest texture, with a delicately tinted bouquet of fading flowers on the work-table at the right. Beatrice, the second sister, who is barefoot in all three versions while her sisters wear canvas shoes, kneels on the floor in one and pauses in her reading to look up at the youngest sister, Silvia, who is absorbed in her book. Differences of age, expression and posture, at this delicate turning point between childhood and girlhood, are admirably conveyed. The calibre of forms and the breadth of folded fabrics, even in these cotton dresses, have the majesty of Doric sculpture. The colour scheme makes play with ochre and grey, mauve and lavender, and from this accomplished orchestration stem the ataraxia of the volumes and the shifting play of lights. The two variations that followed are of like structure and format, but of different tonality. Here the two sisters at either side have changed places. Beatrice, now leaning over a table, has changed her dress and Silvia has put on the funny straw hat that

Seated Nude.
1966. (12 ¹/₄ × 8 ¹/₂ in.)

Katia Reading.
1968-1976. (70 $^1/_2$ × 83 in.)

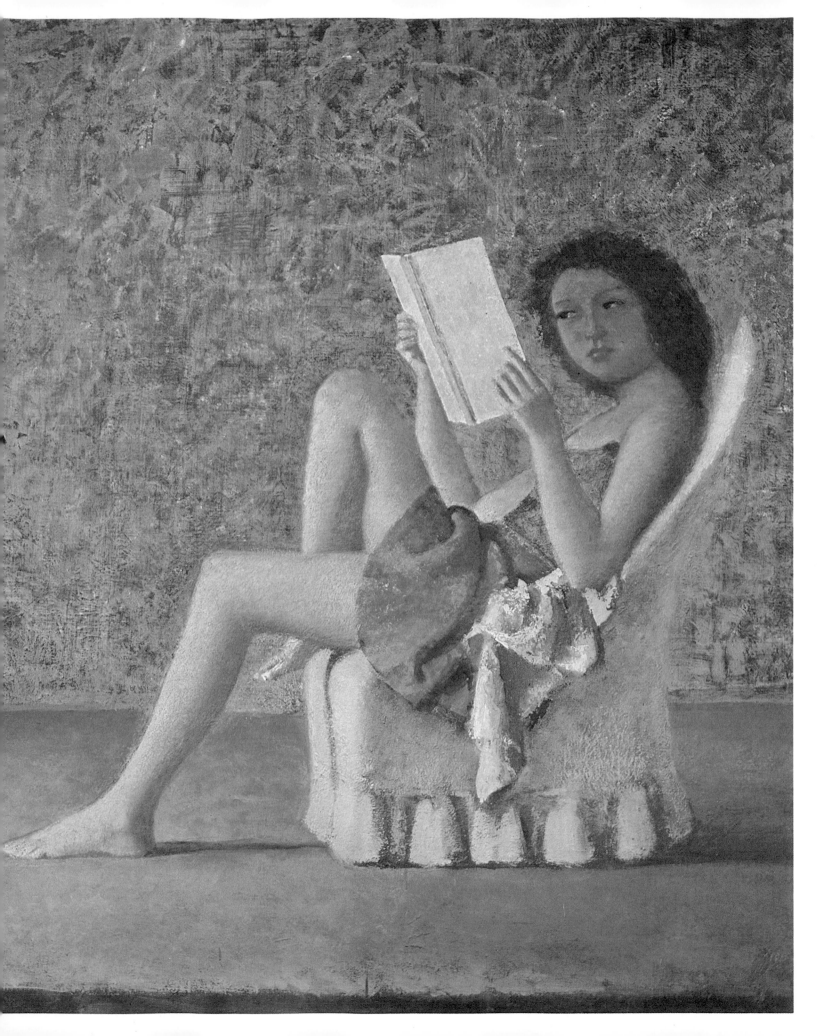

protected a Maillol terracotta. The setting in these two versions is no longer the drawing room at Biarritz but that of the Villa Medici, with its noble proportions, which Balthus had begun to refurnish and whose walls he had repainted in accordance with the old techniques. In the more highly coloured version is a fine Sardinian rug; in the more lightly textured version, a spectral cat. The space of Renaissance painting and its source, the eurhythmy of classical metopes, are here brought together.

The four recent paintings completed in Rome and no less beholden to Mediterranean humanism were posed for or inspired by the two daughters of a lady clerk at the Villa Medici, two Italian sisters incarnating the nobility and beauty of a popular type consecrated by artists. For each of these pictures Balthus reinvented a painting technique of his own, as vulnerable as it is magical in effect, of which painters alone can appreciate the finer points, and he set himself contradictorily to leave the composition open while carrying it to the highest pitch of perfection. The forces involved are not those of a modern experimenter ciphering his private language, but those of a priest of reality and guardian of memory, whose creative responses have to be kept in a state of grace, i.e. on the alert. Everything may be called in question at any moment by the least disturbance of the model or by the chemical deficiency of present-day colours.

Katia Reading is sitting in the easychair that stands in each of the studios provided for the inmates of the Villa Medici. The golden book in her hands catches the light and leaves her face in shadow. The harmonious plenitude of her figure and posture balances the immemorial wall behind her. *Nude Resting* represents her sister Michelina curled up in the same easychair, forming a recess in which her head is turned and bowed in a flower-like movement. The pure smooth marble of her body is delicately shadowed with violet in a green-earth space deliberately left empty, as if in abeyance, where the limp weight of her hand falls free.

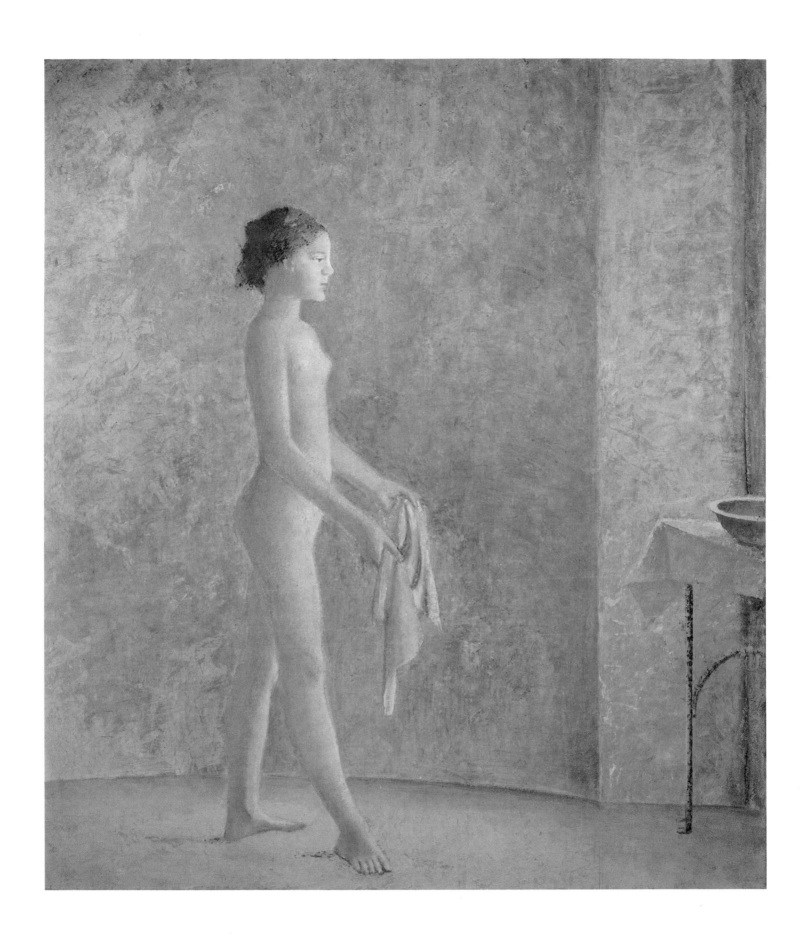

Nude in Profile.
1973-1977. (88 × 79 in.)

Green and violet are the two colours most secretly at work in alchemical transmutations. Adolescence fraught with its cosmic radiance has always been the supreme model of beauty because in the litheness of its still growing form there is a slight wavering which imparts the breath of life to the perfection of its outline. The body is the mirror of the relations between man and the world. Since Bonnard and Derain contemporary art has refused or is powerless to give an image of the body–the body being either repudiated by critical irony in the manner of Marcel Duchamp or ravaged by expressionist anguish and its obsession with ugliness. Ugliness is not so much an aesthetic perversion as an ontological lacuna, the inadequateness of form to its content. Love alone is capable of maintaining the presence of being and disclosing reality. *Nude in Profile* is a stubborn act of love in the effort to save that beauty which, Dostoyevsky tells us, is more indispensable than ever in a soulless world, even while remaining an enigma. Standing in contrapposto in a rotunda beside a wrought-iron table, the child-woman of heavenly proportions, who cannot but remain the wonder of creation and whose arms at first were raised up in salutation to the dawn, seems to arise from the depth of the ages and holds before her the ritual bath towel on which the gold of time is crystallized. His preparatory drawings Balthus had considered as so many trial sketches and usually destroyed them, but since the exhibition of them which he consented to hold in Paris at the Galerie Claude Bernard in 1971, he has enlarged their format and treated them as independent works. A few of his drawings are reproduced here. Drawings without any stylization, the medium being chiefly charcoal and soft black pencil. They seem to well up of themselves, by grace and not by a masterly command of the medium, and to comply with their object and answer to that inner meaning evoked by Plotinus: "that sense of the beautiful arises perhaps by comparing the object with the design of it harboured in the soul, a design which the soul refers to in order to pass judgment on it, just as a rule enables one to judge whether a line is perfectly straight."

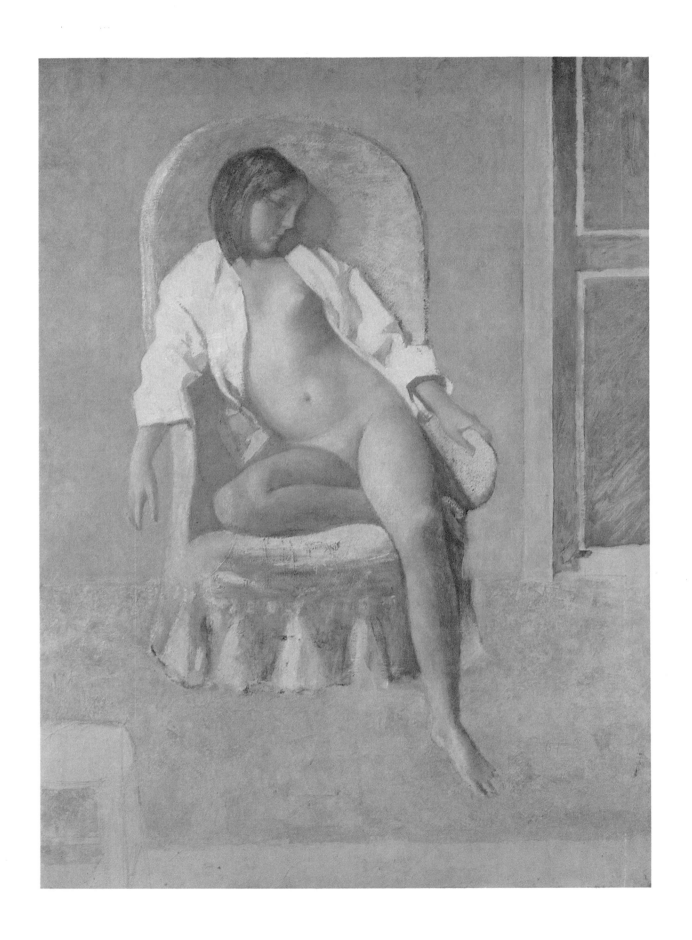

Nude Resting.
1977. (78 ³⁄₄ × 59 in.)

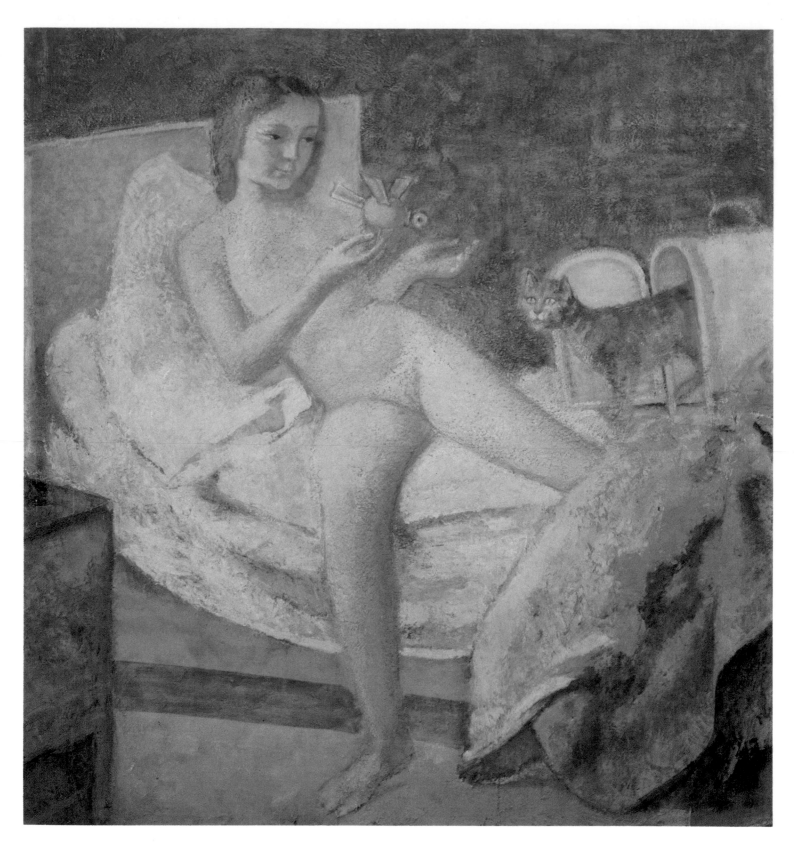

Getting Up.
1975-1978. (66 $^1/_2$ × 62 $^3/_4$ in.)

Girl on Her Knees. *(39 ³/₈ × 27 ¹/₂ in.)*

Getting Up underwent many changes and repaintings before reaching its Rembrandtesque density, and before it finally included the glowing-eyed cat bursting from its basket and the toy bird made of wood. In ancient China a cat's eyes responding to the sunlight and piercing the night were regarded as living timepieces. A set of Balthus' childhood drawings published and prefaced by Rilke (*Mitsou,* 1921) depict the story of a cat found in joy and lost in tears. The ghost of that cat mysteriously lost returns again and again to haunt his pictures. But what, asked Rilke, is the attitude of cats? "Cats are simply cats and their world is the world of cats, from first to last." So is the world of Balthus a painter's world, bright with unfading lights.

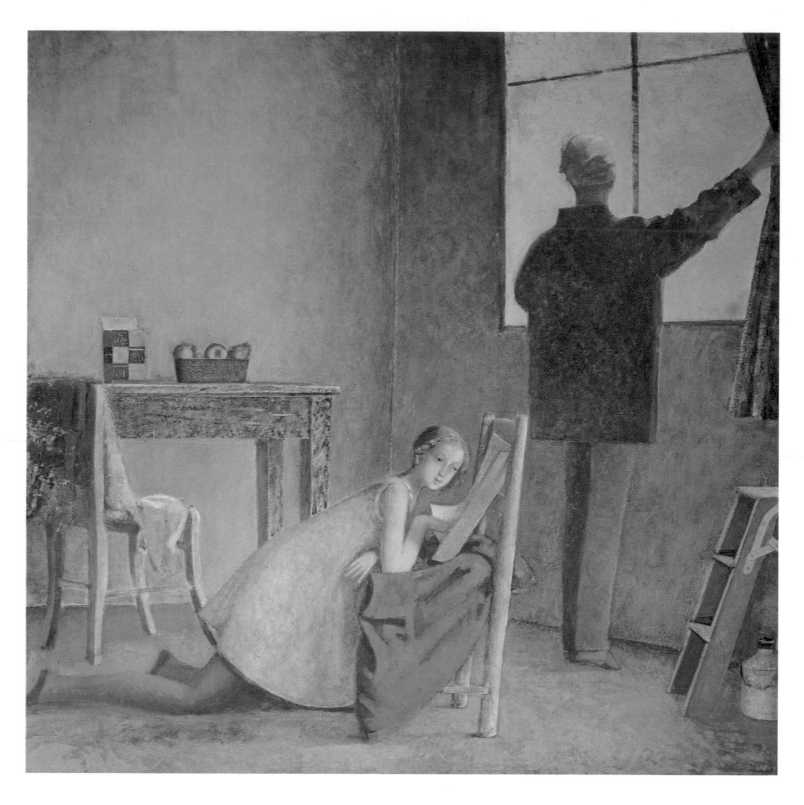

The Painter and His Model.
1980-1981. (89 $^1/_4$ × 91 $^3/_4$ in.)
Musée National d'Art Moderne,
Centre Georges Pompidou, Paris.

Monte Calvello.
(39 ³/₈ × 27 ¹/₂ in.)

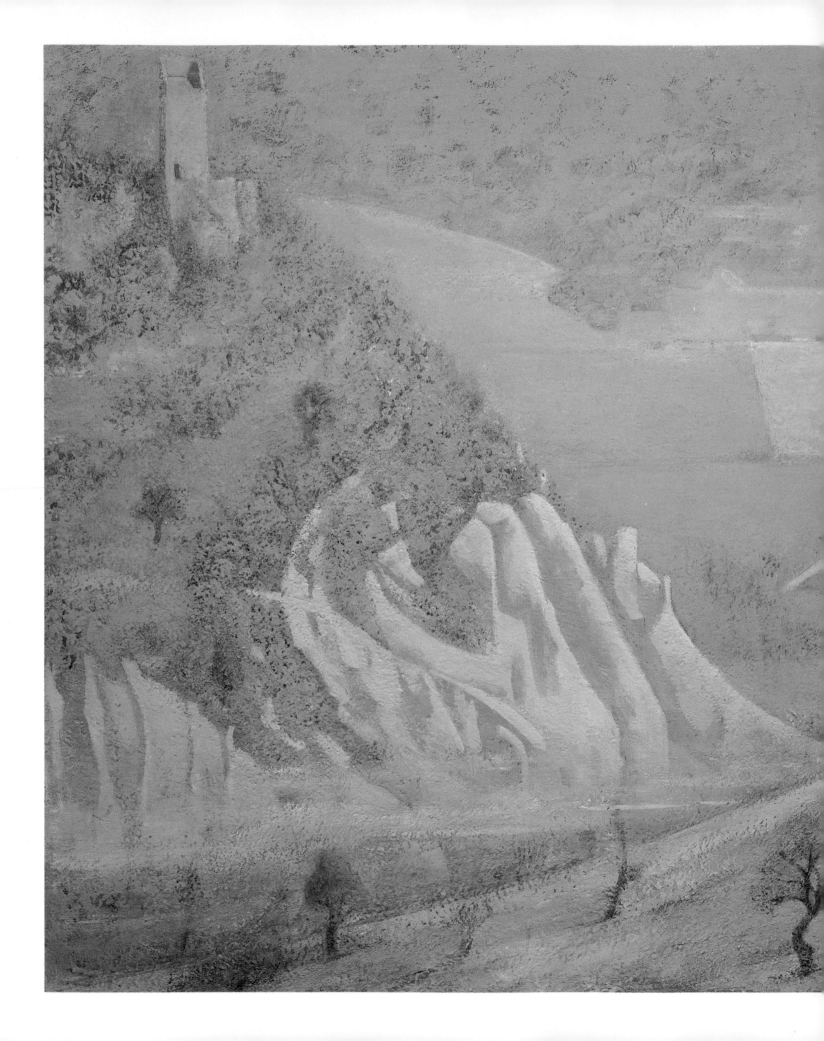

View of Monte Calvello.
1979. (51 ³/₈ × 63 ³/₄ in.)
Musée National d'Art Moderne,
Centre Georges Pompidou, Paris.

We are most grateful to all those who have helped us to locate photographs of the works reproduced. Most collectors having expressed the desire to remain anonymous, we have indicated whereabouts only for works in public museums.

Our particular thanks are due to the following galleries: Lee Ault Gallery, New York; Galerie Claude Bernard, Paris; Galleria Galatea, Turin; Galerie Henriette Gomès, Paris; Galerie Jan Krugier, Geneva; Lefevre Gallery, London; Pierre Matisse Gallery, New York.

*Pictures marked with an asterisk * are reproduced in colour in the main section of the book.*

Street Scenes

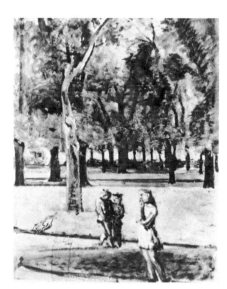

The Luxembourg Gardens, c. 1927.
(24¾ × 20″)

The Luxembourg Gardens, 1929.

Place de l'Odéon, 1928.

The Quays, 1929.
(28 × 23″)

The Quays, 1929.

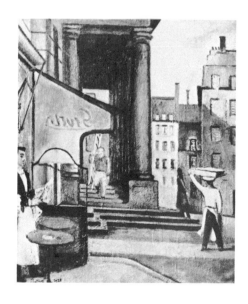

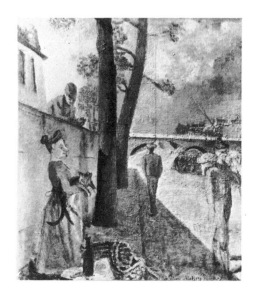

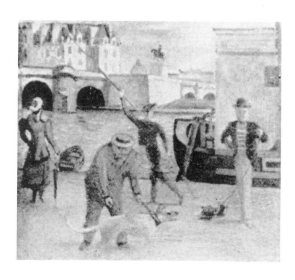

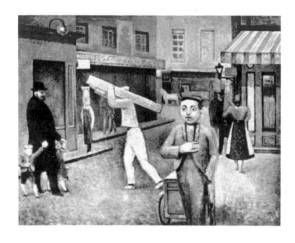

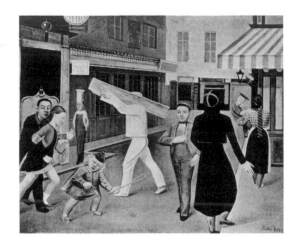

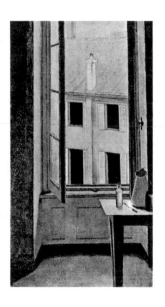

The Street, 1929.
(51 × 63")

* The Street, 1933.
(76 × 94¼")
The Museum of Modern Art, New York.

* The Window, Cour de Rohan, 1949–1952.
(32¼ × 19¾") Collection Pierre Lévy,
Donation to the French National Museums.

Study for *The Passage du Commerce Saint-André*.

* The Passage du Commerce Saint-André, 1952–1954.
(115½ × 130¼")

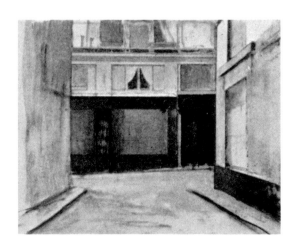

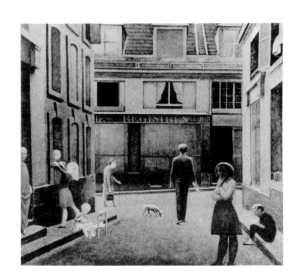

Portraits

Communicant, 1925.

Pierre Laprin, 1934.
(16½ × 13¼″)

Madame Pierre Loeb, 1934.
(27½ × 20⅛″)

Roger and His Son, c. 1936.

Portrait of a Lady, 1935.
(31½ × 21¾″)
Fondation Waechter, Geneva.

The Sub-Prefect of Pontoise, 1936.
(42½ × 49¼″)
Fondation Waechter, Geneva.

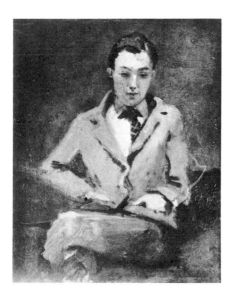

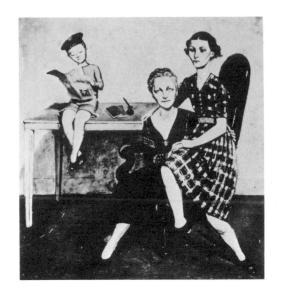

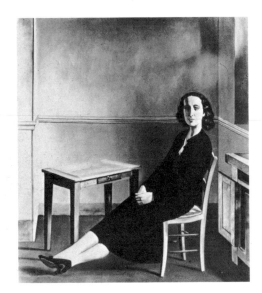

Pierre Matisse, 1935 (lost).

Cassandre-Mouron Family, 1935.
($28^{3}/_{8} \times 28^{3}/_{8}''$)
Fondation Waechter, Geneva.

Portrait of the Vicomtesse de Noailles, 1936.
($61^{1}/_{4} \times 53^{1}/_{8}''$)

* André Derain, 1936.
($44^{3}/_{8} \times 28^{1}/_{2}''$)
The Museum of Modern Art,
New York.

* Joan Miró and his Daughter Dolores, 1937-1938.
($51^{1}/_{4} \times 35''$)
The Museum of Modern Art, New York.

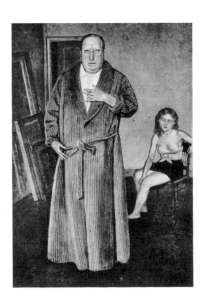

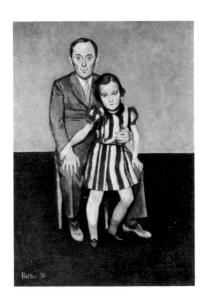

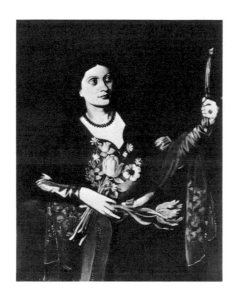

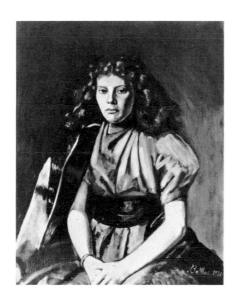

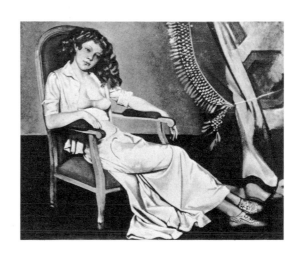

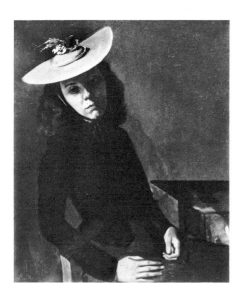

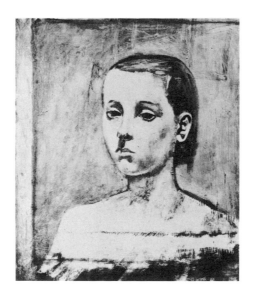

Portrait of an Actress, 1937.

Girl with a Blue Belt, 1937.
(36 × 27")

*The White Skirt, 1936-1937.
(51¼ × 63¾")

The Bernese Hat, 1938-1939.
(51¼ × 36⅛")

Thérèse, 1938.
(21¾ × 18¼")

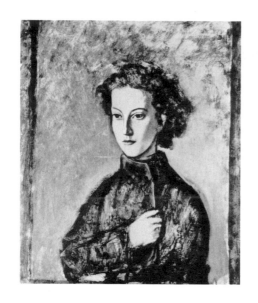 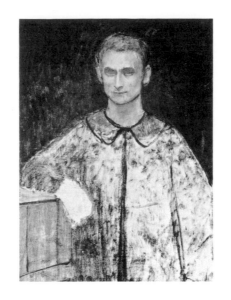

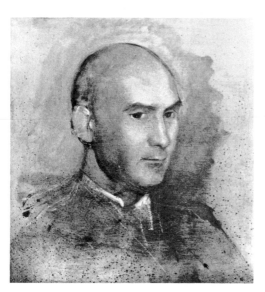 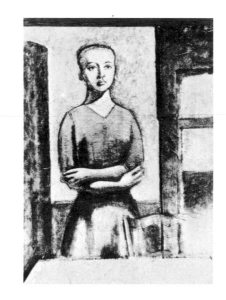 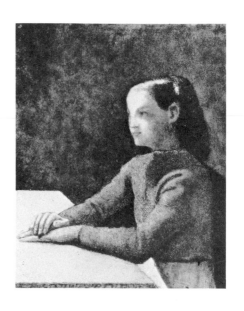

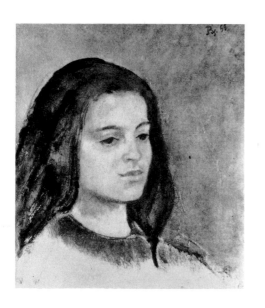 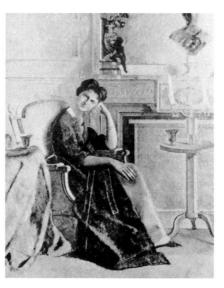

Portrait of R.S., 1949.
($23^5/_8 \times 19^1/_8''$)

Self-Portrait, 1949-1950.
($46 \times 32''$)

Boris Kochno, 1951.
($19^1/_8 \times 17^3/_8''$)

Portrait, 1954.
($39^3/_4 \times 25^5/_8''$)

* Colette in Profile, 1954.
($36^1/_2 \times 29''$)

Study, 1955.
($19^1/_2 \times 15^3/_4''$)

Portrait of the Baronne
Alain de Rothschild, 1958.
($74^3/_4 \times 59^3/_4''$)

Interior Scenes
and Related Subjects

The Window, 1933.
(63¾ × 43⅞")
Indiana University Art Museum, Bloomington.

* The Children (Hubert and Thérèse Blanchard), 1937.
(49¼ × 50¾")
Pablo Picasso Donation, Louvre, Paris.

* The Greedy Child, 1937-1938.
(36¼ × 28¾")

Still Life, 1937.
(32 × 39") Wadsworth Atheneum, Hartford.

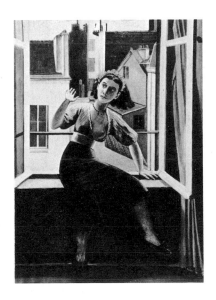

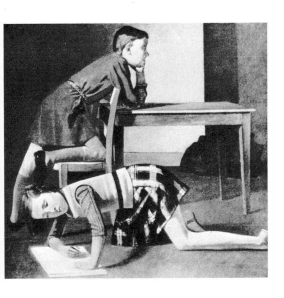

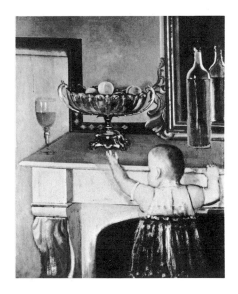

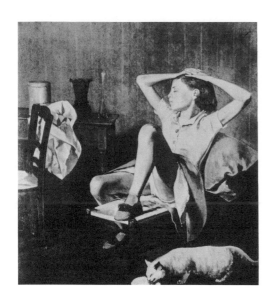
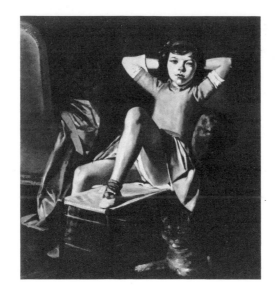
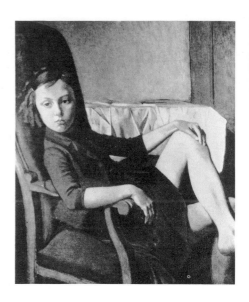

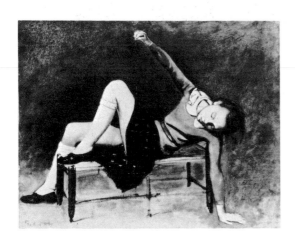
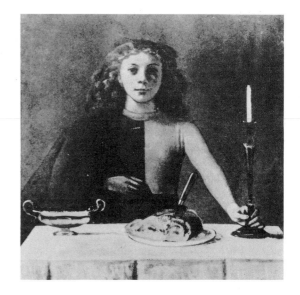

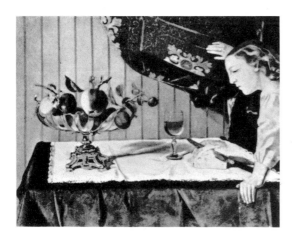

Girl and Cat, 1937.
(34½ × 30¾'')

The Dream (Thérèse and Her Cat), 1938.
(59¼ × 51¼'')

Thérèse, 1938.
(55 × 30'')

Thérèse Lying on a Bench, 1939.
(28 × 36'')

Girl in Green and Red (The Candlestick), 1939.
(36 × 35½'') The Museum of Modern Art, New York.

Tea Time, 1940.
(28¾ × 36¼'')

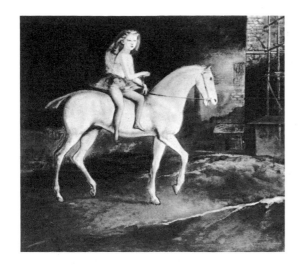

Girl on a White Horse, 1941.
(31½ × 35½″)
Thyssen-Bornemisza Foundation,
Lugano.

* The Living Room, 1941-1943.
(45 × 58″) The Minneapolis Institute of Arts.

The Living Room, 1942.
(45 × 57½″)

Sleeping Girl, 1943.
(32¼ × 39½″) Tate Gallery, London.

Patience, 1943.
(63³/₈ × 64½″) The Art Institute of Chicago.

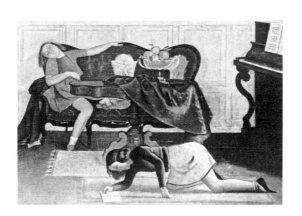

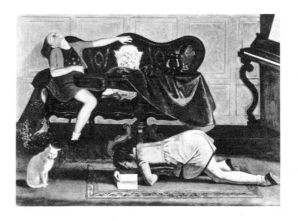

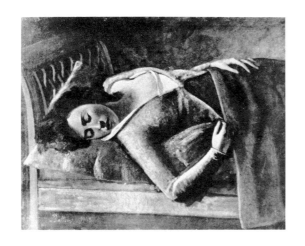

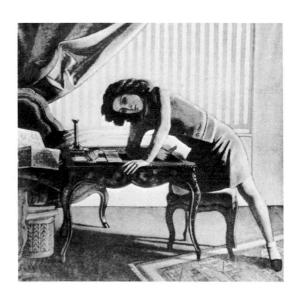

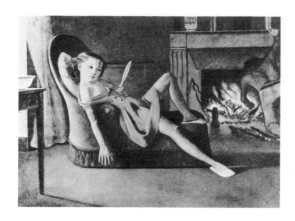

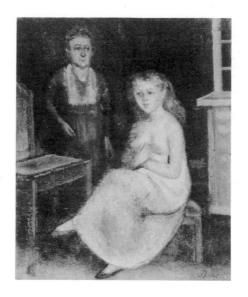

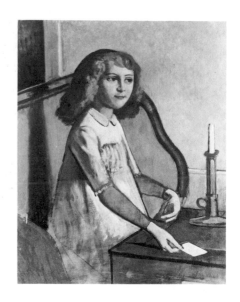

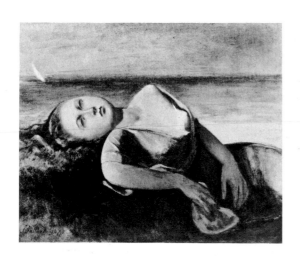

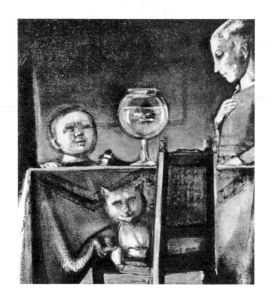

* The Golden Days, 1944-1949.
(58¾ × 78¾″) Hirshhorn Museum,
Smithsonian Institution,
Washington, D.C.

The Girl, 1946.
(16 × 13″)

The Game of Cards, 1944-1945.
(35 × 34¼″)

Woman Lying Down, 1947.
(20 × 25¼″)

Girl with Goldfish, 1948.
(24½ × 22″)

Girl with Goldfish, 1949.
(21⅞ × 24½″)

Goldfish and Candle, 1949.

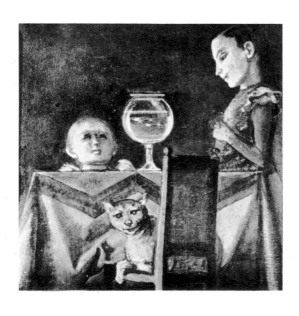

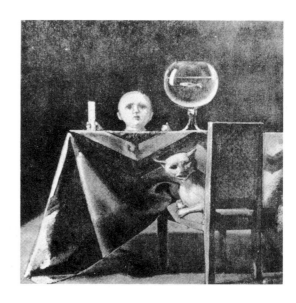

132

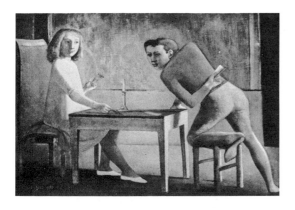

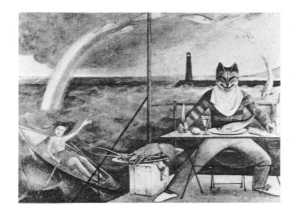

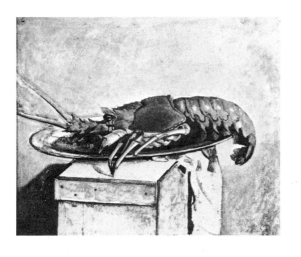

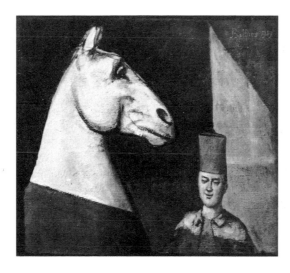

Patience, 1948.
(24¾ × 36¼″)

* The Méditerranée's Cat, 1949.
(50 × 72¾″)

The Lobster, 1949.
(25⅝ × 32″)

The Spahi and His Horse, 1949.
(23¼ × 27¼″) Hirshhorn Museum,
Smithsonian Institution,
Washington, D.C.

The Four Thursdays, 1949.
(38½ × 33″)

Woman Putting on Her Shoes, 1950.
(26 × 21½″)

The Game of Cards, 1952.
(25¼ × 31½″)

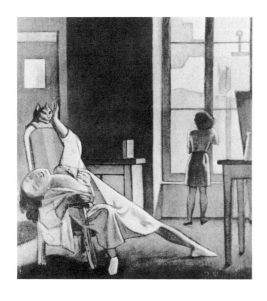

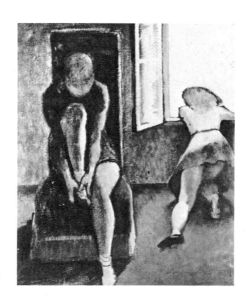

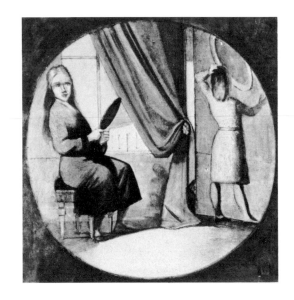

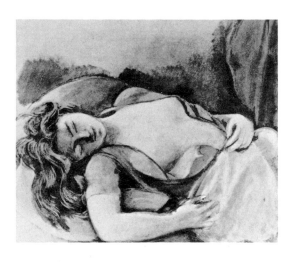

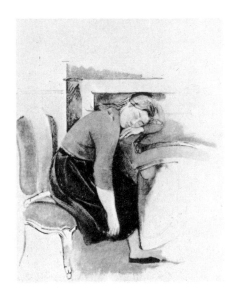

Solitaire, 1954-1955.
(35½ × 34¾″)

Still Life, 1954.
(10½ × 14″)

Young Girl Sleeping, 1954.
(18¼ × 21¼″)

Early Morning, 1954.
(28½ × 28½″)

Young Girl Sleeping, 1955.
(18¼ × 22″)

Young Girl Asleep, 1955.
(45½ × 35″) Philadelphia Museum of Art.

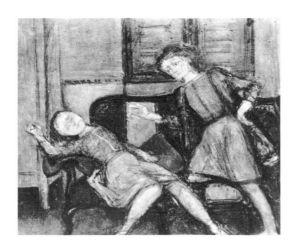 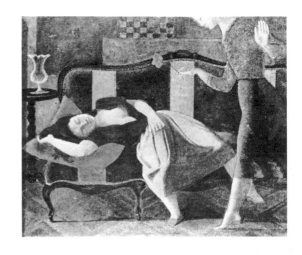

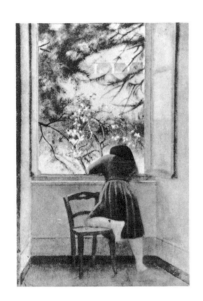

Study for *The Dream I*, 1955.
(18 × 22″)

* The Dream I, 1955-1956.
(51¼ × 63¾″)

* Girl at the Window, 1955.
(77¼ × 51¼″)

* Fruit on a Window Sill, 1956.
(26¼ × 34″)

Study for *The Fortune Teller*, 1956.
(39 × 25⅝″)

* The Fortune Teller, 1956.
(78¾ × 78¾″)

Girl Reading, 1957.
(63¾ × 51¼″)

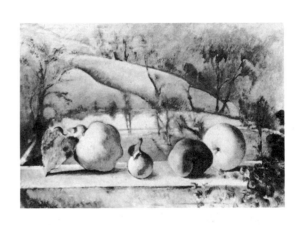

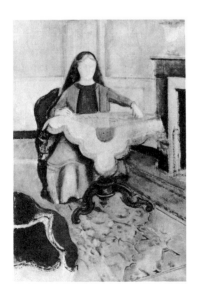 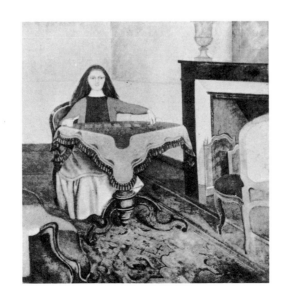 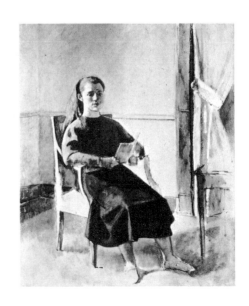

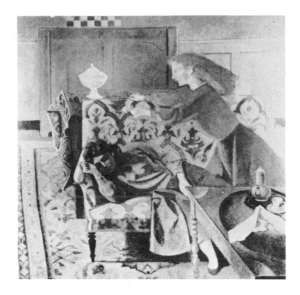

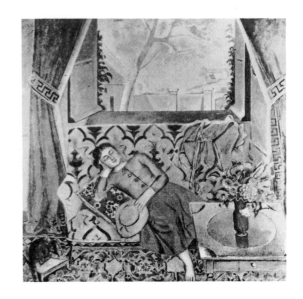

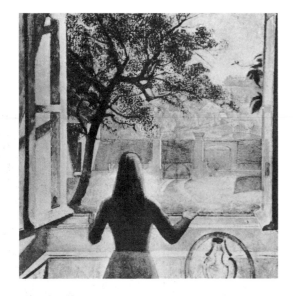

The Dream II, 1956-1957.
(78 × 78″)

Golden Afternoon, 1957.
(78 × 78″)

* Girl at the Window, 1957.
(63 × 63¾″)

* Boy with Pigeons, 1959-1960.
(63¾ × 51½″)

Still Life with Lamp, 1958.
(63¾ × 51¼″)

Still Life in the Studio, 1958.
(28¾ × 23⅝″)

* The Cup of Coffee, 1959-1960.
(64 × 51¼″)

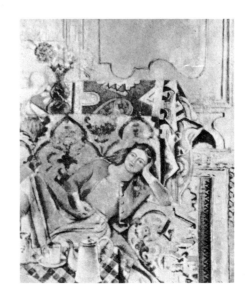

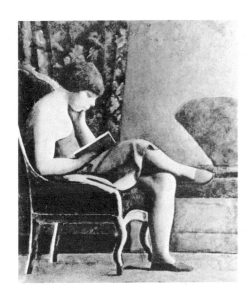
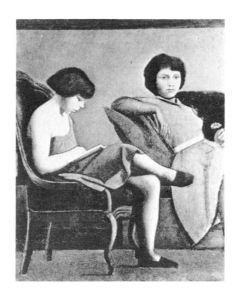
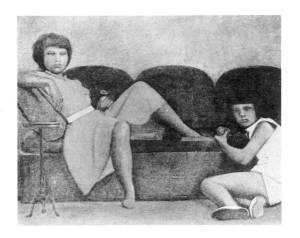

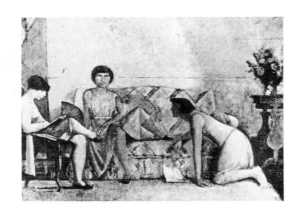

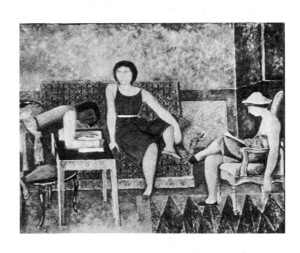

Colette Reading, 1954.
(39 × 32″)

Study for *The Three Sisters*, 1954.
(39 × 32″)

Study for *The Three Sisters*, 1954.
(32 × 45¾″)

* The Three Sisters, 1960–1965.
(51¼ × 75½″)

* The Three Sisters, 1964–1965.
(50 × 67″)

* The Three Sisters, 1966.
(51½ × 69″)

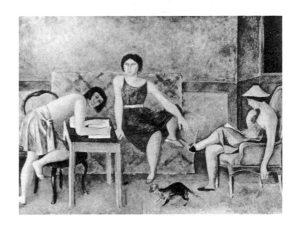

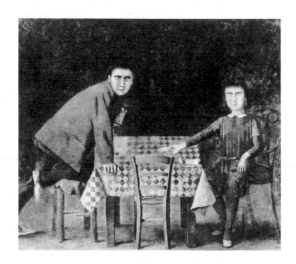

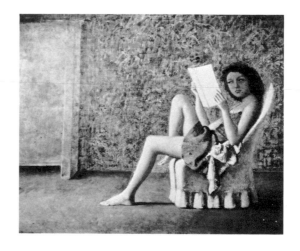

Fruit on a Plate, 1963.
($15^5/_8 \times 19^3/_4''$)
Fondation Waechter, Geneva.

* The Card Game, 1968-1973.
($74^3/_4 \times 88^1/_2''$) Boymans-van Beuningen
Museum, Rotterdam.

* Katia Reading, 1968-1976.
($70^1/_2 \times 83''$)

* The Painter and His Model, 1981.
($89^1/_4 \times 91^3/_4''$) Centre Georges Pompidou, Paris.

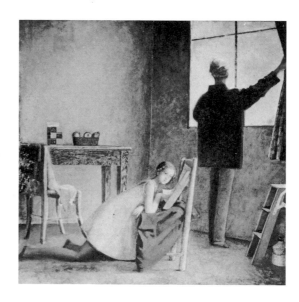

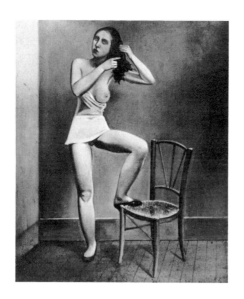

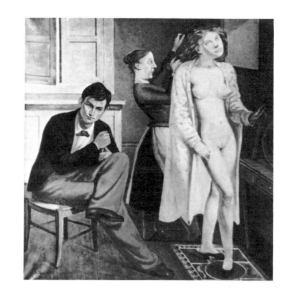

Nudes

Alice, 1933.

Cathy Dressing, 1933.
(65 × 59″)
Centre Georges Pompidou, Paris.

The Guitar Lesson, 1933.
(63 ½ × 54 ½″)

The Victim, 1937.
(52³/₈ × 86 ½″)

Reclining Nude, 1945?
(17 ½ × 23 ½″)

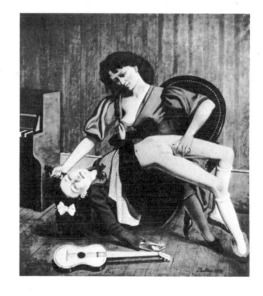

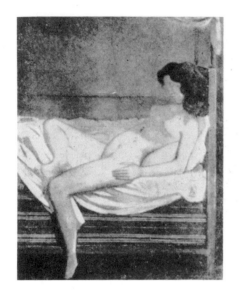 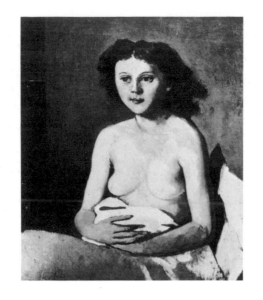

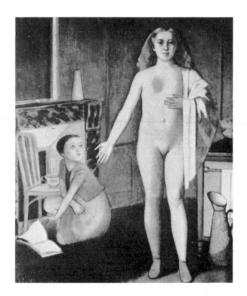 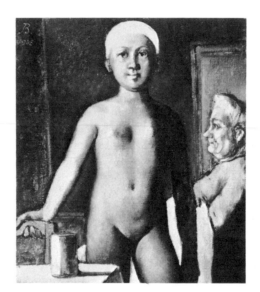 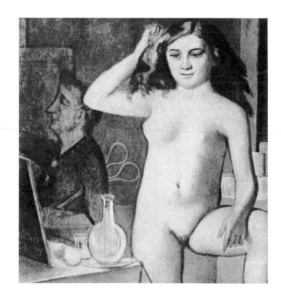

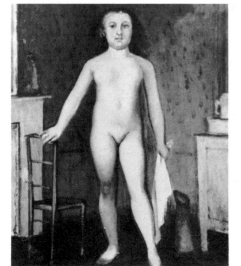

A Reclining Nude, c. 1938.

Young Woman Sitting, 1947.
($17\frac{3}{4} \times 14\frac{5}{8}''$)

The Room, 1947–1948.
($74\frac{3}{4} \times 63''$) Hirshhorn Museum,
Smithsonian Institution, Washington, D.C.

Girl Getting Dressed, 1948.
($21\frac{1}{4} \times 17\frac{5}{8}''$)

Georgette Dressing, 1948–1949.
($38 \times 36\frac{1}{4}''$)

Study for a Bather, 1949.
($24 \times 19\frac{1}{2}''$) Yale University
Art Gallery, New Haven.

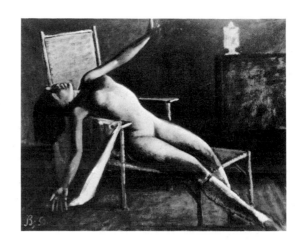

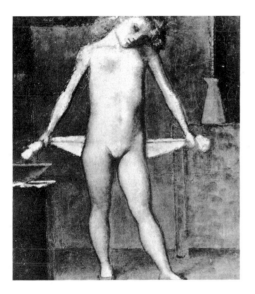

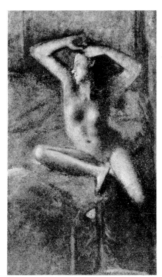

Sketch, 1949.
(21¼ × 25⅝″)

Nude in an Armchair, 1950.

Girl Dressing, 1950.
(28¾ × 23½″)

Nude Girl with Raised Arms, 1951.
(59 × 32¼″)

Girl Dressing, 1952/1953–1960.
(59½ × 33½″)

*The Room, 1952–1954.
(106½ × 130″)

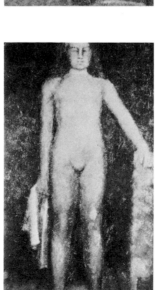

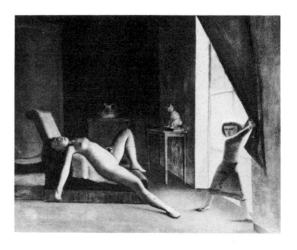

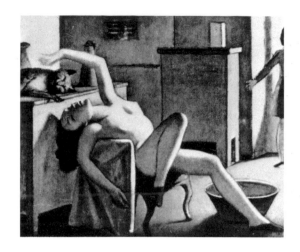

Nude with Cat, c. 1954.
($25\frac{5}{8} \times 31\frac{3}{4}''$) National Gallery
of Victoria, Melbourne.

Sketch for *Getting Up*.

Getting Up, 1955.
($63\frac{3}{4} \times 51\frac{1}{4}''$)

Woman in a Bathtub, 1955.
($63 \times 63\frac{3}{4}''$)

Study for *Girl in White*.

* Girl in White, 1955.
($46 \times 35''$)

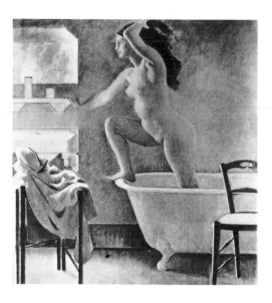

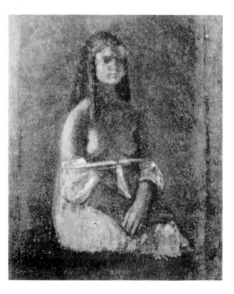

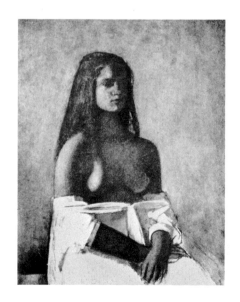

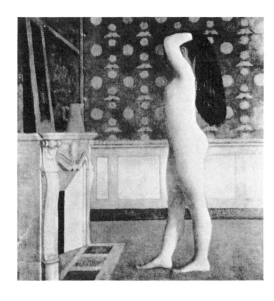
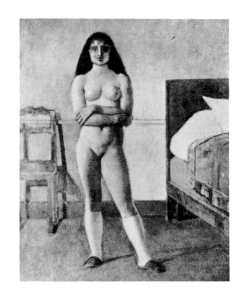

* Nude in Front of a Mantel, 1955.
(77 × 64½″)
The Metropolitan Museum of Art, New York.

Nude with a Chair, 1957.
(63¾ × 51¼″)

* The Toilette, 1957.
(63 × 51¼″)

The Toilette, 1958.
(28¾ × 23⅝″)

Girl with a Blue Towel, 1958.
(63¾ × 38¼″)

The Bather, 1960.
(63¾ × 45″)

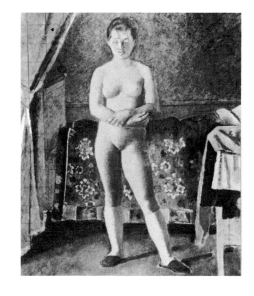
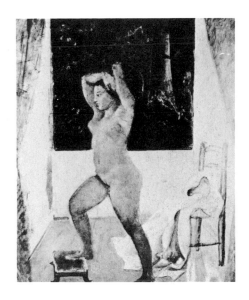

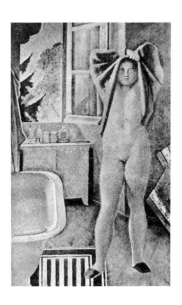
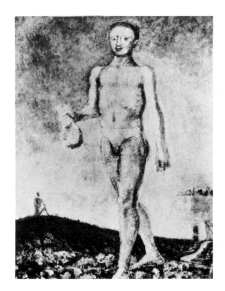

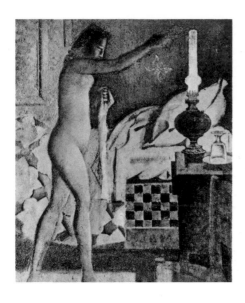

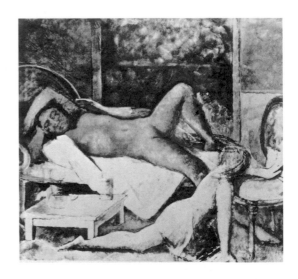

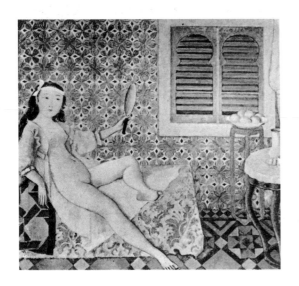

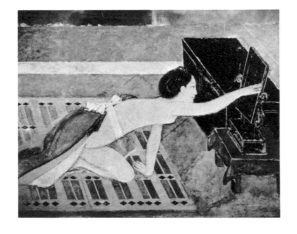

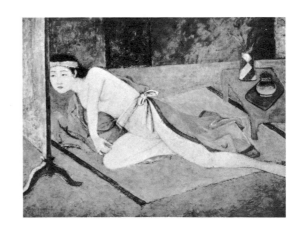

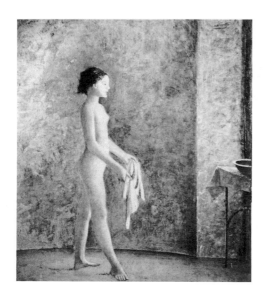

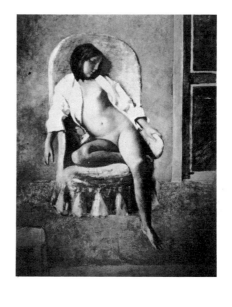

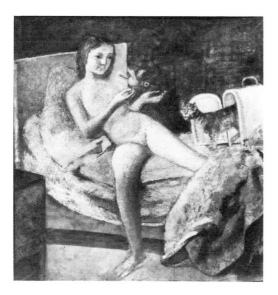

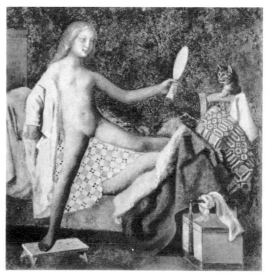

* Nude in Profile, 1973-1977.
(88 × 79″)

* Nude Resting, 1977.
(78¾ × 59″)

* Getting Up, 1975-1978.
(66½ × 62¾″)

The Cat in the Mirror, 1977-1980.
(71 × 67″)

Nude Resting, 1980.
(78¾ × 59″)

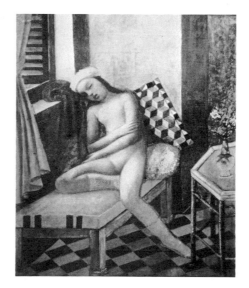

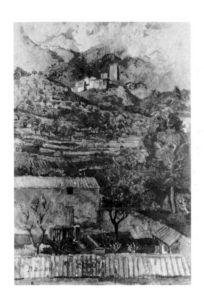

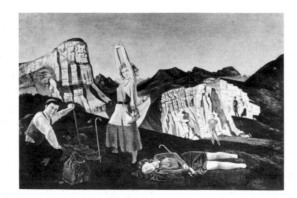

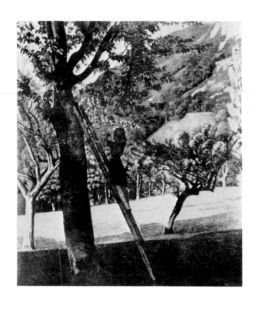

Landscapes

Landscape in Provence, 1925.
(29½ × 19¼") Collection Pierre Lévy,
Donation to the French National Museums.

* The Mountain, 1935-1937.
(99 × 144½")

* Larchant, 1939.
(51¼ × 63¾")

* The Cherry Tree, 1942.
(36½ × 28¾")

* Landscape at Champrovent, 1942-1945.
(38½ × 51¼")

* Landscape with Oxen, 1942.
(28³⁄₈ × 39³⁄₈")

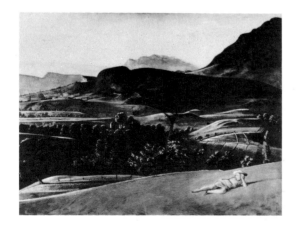

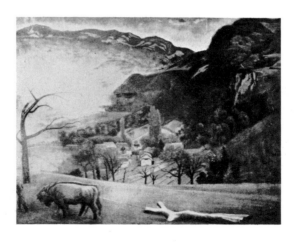

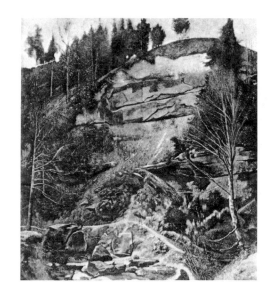

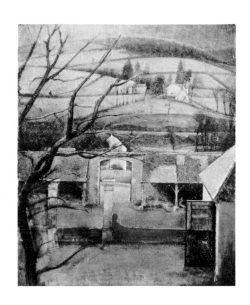

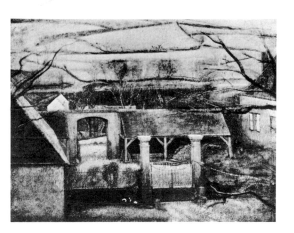

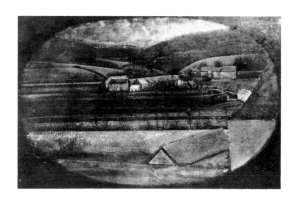

* Italian Landscape, 1951.
(23 ¼ × 34 ¼")

* Gottéron Landscape, 1943.
(45 ¼ × 39 ¼")

Farm at Chassy, Winter, 1954.
(39 ¾ × 32")

The Farmyard, 1954.
(29 ½ × 36 ¾")

Winter Landscape, 1954.
(23 ¼ × 35 ¾")

The Valley of the Yonne, 1957.
(22 ¾ × 36 ¼") Collection Pierre Lévy,
Donation to the French National Museums.

* Big Landscape with Trees
(The Triangular Field), 1955.
(45 × 63 ¾")

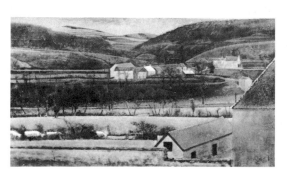

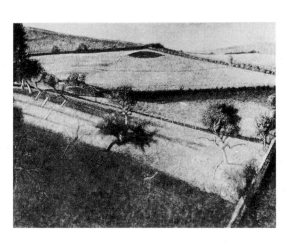

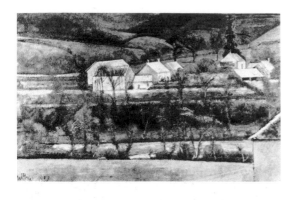

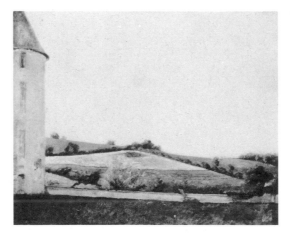

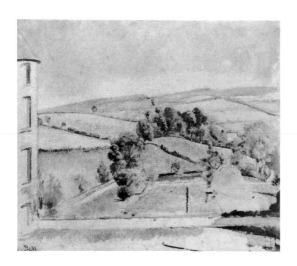

The Valley of the Yonne, 1956.
($22\frac{3}{4} \times 36\frac{1}{4}''$)

Landscape, 1956.
($25\frac{5}{8} \times 31\frac{7}{8}''$)

Landscape, 1957.
($29\frac{1}{2} \times 35\frac{1}{2}''$)

Landscape with Cows, 1958.
($31\frac{1}{2} \times 25\frac{3}{4}''$)

*Bouquet of Roses on a Window Sill, 1958.
($52\frac{3}{4} \times 51\frac{1}{2}''$) Indianapolis Museum of Art.

The Farmyard, 1958.
($31\frac{7}{8} \times 39\frac{3}{8}''$)

Farm at Chassy, Summer, 1958.
($45\frac{1}{2} \times 34\frac{1}{2}''$)

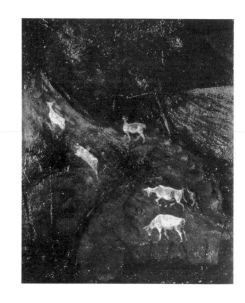

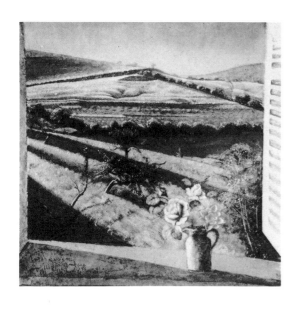

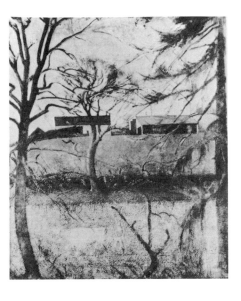

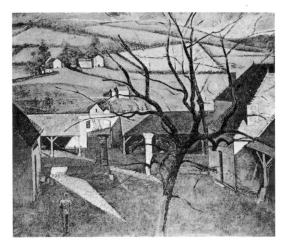

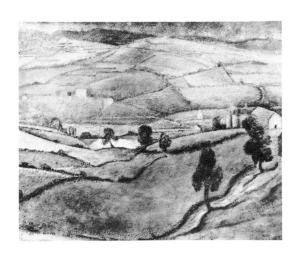

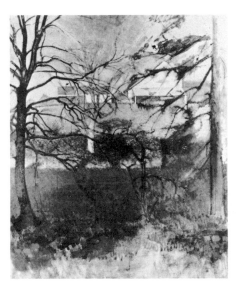

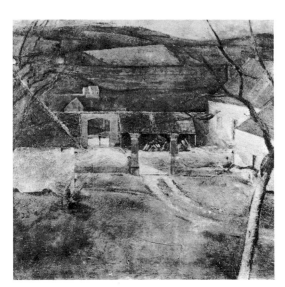

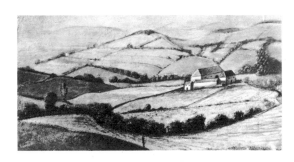

* Big Landscape with Cow, 1958-1960.
 $(64 \times 51\frac{1}{4}'')$

* Big Landscape with Tree, 1960.
 $(51\frac{1}{4} \times 63\frac{3}{4}'')$

 The Farm, 1959-1960.
 $(32\frac{1}{2} \times 39\frac{3}{8}'')$

 Landscape, 1960.

* Farmyard at Chassy, 1960.
 $(35 \times 37\frac{3}{4}'')$

* La Bergerie, 1960.
 $(19\frac{3}{4} \times 39\frac{3}{8}'')$

 Landscape, 1960.
 $(55 \times 61\frac{1}{2}'')$

* Landscape at Monte Calvello, 1979.
 $(51\frac{1}{8} \times 63\frac{3}{4}'')$

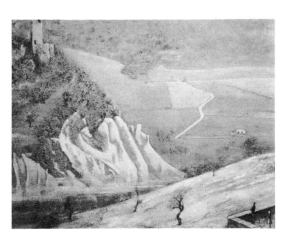

List of Illustrations

PRINTED BY
IMPRIMERIES RÉUNIES S.A., LAUSANNE

BINDING BY
GROSSBUCHBINDEREI H.+J. SCHUMACHER AG
SCHMITTEN (FRIBOURG)

Printed in Switzerland